THE CITY IN A GARDEN

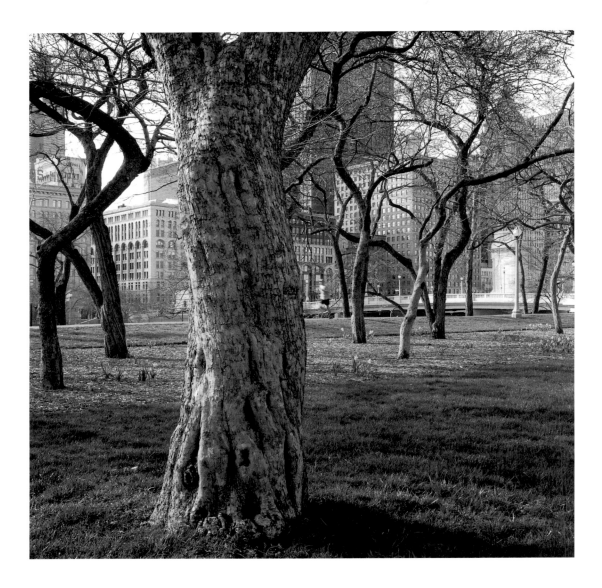

On Labor Day of 2001 this book is dedicated to all those who have made Chicago
a city in a garden, and to all those who will work in the future to make a difference
in how we care for and carry on with this parkland legacy.

THE CITY IN A GARDEN

A Photographic History
of Chicago's Parks

Text by Julia Sniderman Bachrach

Foreword by Bill Kurtis

Contemporary Photographs
by Judith Bromley and James Iska

and historic images from
the Chicago Park District's
Special Collections

PUBLISHED BY
THE CENTER FOR AMERICAN PLACES
PLACITAS AND SANTA FE, NEW MEXICO
HARRISONBURG, VIRGINIA

IN ASSOCIATION WITH
THE CHICAGO PARK DISTRICT

PUBLISHER'S NOTES:

The City in a Garden: A Photographic History of Chicago's Parks is the inaugural volume in a new series entitled *Center Books on Chicago and Environs,* created by the Center for American Places. The series is supported in part by a grant from the Graham Foundation for Advanced Studies in the Fine Arts, for which the publisher is most grateful. The book was also brought to publication with the generous financial assistance of the Chicago Park District, with additional support from CITY 2000 and the Parkways Foundation.

The clothbound version is issued in a limited collector's edition of 1,000 copies, never to be reprinted.

Some of the historic photographs in Ms. Bachrach's introduction, "A History of Chicago's Parks," were cropped ever so slightly to accommodate the book's trim size. All other historic and contemporary images appear full frame.

Frontispiece: Grant Park, Spring, 2000, by James Iska. Many groupings of crabapple trees in Grant Park were originally planted during the 1930s.

The Center for American Places, Inc.
P.O. Box 23225
Santa Fe, New Mexico 87502, U.S.A.
www.americanplaces.org

Published 2001. First edition.

Distributed by the University of Chicago Press
1427 East 60th Street
Chicago, IL 60637-2954
www.press.uchicago.edu

9 8 7 6 5 4 3 2

Library of Congress Cataloging-in-Publication Data

Bachrach, Julia Sniderman, 1960-
 The city in a garden : a photographic history of Chicago's parks/text by Julia Sniderman Bachrach ; foreword by Bill Kurtis ; contemporary photographs by Judith Bromley and James Iska and historic images from the Chicago Park District's Special Collections. p. cm.
 Includes bibliographical references.
 ISBN 1-930066-01-5 — ISBN 1-930066-02-3 (pbk.)
 1. Urban parks—Illinois—Chicago—History—Pictorial works. 2. Urban parks—Illinois—Chicago—History. 3. Chicago (Ill.)—History--Pictorial works. 4. Chicago (Ill.)—History. 5. Photography, Artistic. I. Title.
 F548.65.A1 B34 2001
 977.3'11--dc21

 2001032476

A city, like a living thing,

is a united and continuous whole.

—*Plutarch (ca. A.D. 50-120),* Moralia

Each generation writes its own

biography in the cities it creates.

—*Lewis Mumford (1895-1990),* The Culture of Cities

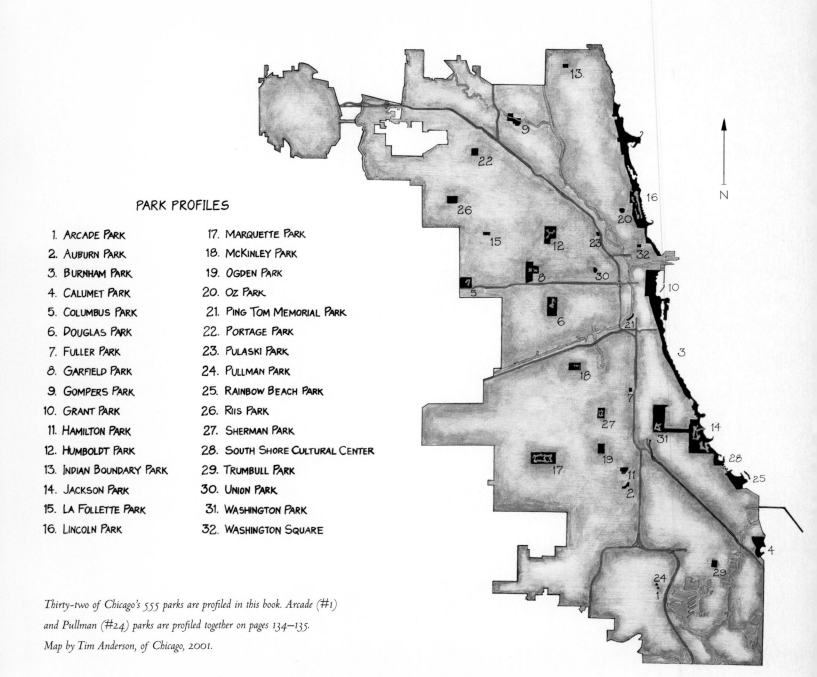

PARK PROFILES

1. ARCADE PARK
2. AUBURN PARK
3. BURNHAM PARK
4. CALUMET PARK
5. COLUMBUS PARK
6. DOUGLAS PARK
7. FULLER PARK
8. GARFIELD PARK
9. GOMPERS PARK
10. GRANT PARK
11. HAMILTON PARK
12. HUMBOLDT PARK
13. INDIAN BOUNDARY PARK
14. JACKSON PARK
15. LA FOLLETTE PARK
16. LINCOLN PARK

17. MARQUETTE PARK
18. MCKINLEY PARK
19. OGDEN PARK
20. OZ PARK
21. PING TOM MEMORIAL PARK
22. PORTAGE PARK
23. PULASKI PARK
24. PULLMAN PARK
25. RAINBOW BEACH PARK
26. RIIS PARK
27. SHERMAN PARK
28. SOUTH SHORE CULTURAL CENTER
29. TRUMBULL PARK
30. UNION PARK
31. WASHINGTON PARK
32. WASHINGTON SQUARE

N

Thirty-two of Chicago's 555 parks are profiled in this book. Arcade (#1)
and Pullman (#24) parks are profiled together on pages 134–135.
Map by Tim Anderson, of Chicago, 2001.

Contents

Foreword, by Bill Kurtis *ix*

A History of Chicago's Parks
by Julia Sniderman Bachrach *3*

Notes to the Essay *35*

Park Profiles

Auburn *38*

Burnham *40*

Calumet *44*

Columbus *48*

Douglas *54*

Fuller *60*

Garfield *62*

Gompers *68*

Grant *70*

Hamilton *76*

Humboldt *80*

Indian Boundary *88*

Jackson *92*

La Follette *102*

Lincoln *104*

Marquette *112*

McKinley *116*

Ogden *120*

Oz *124*

Ping Tom Memorial *126*

Portage *128*

Pulaski *132*

Pullman and Arcade *134*

Rainbow Beach *136*

Riis *138*

Sherman *142*

South Shore Cultural Center *148*

Trumbull *150*

Union *152*

Washington *156*

Washington Square *162*

Glossary of Key Figures, Terms,
and Organizations *165*

Suggested Readings *171*

Acknowledgments *173*

About the Author and Photographers *175*

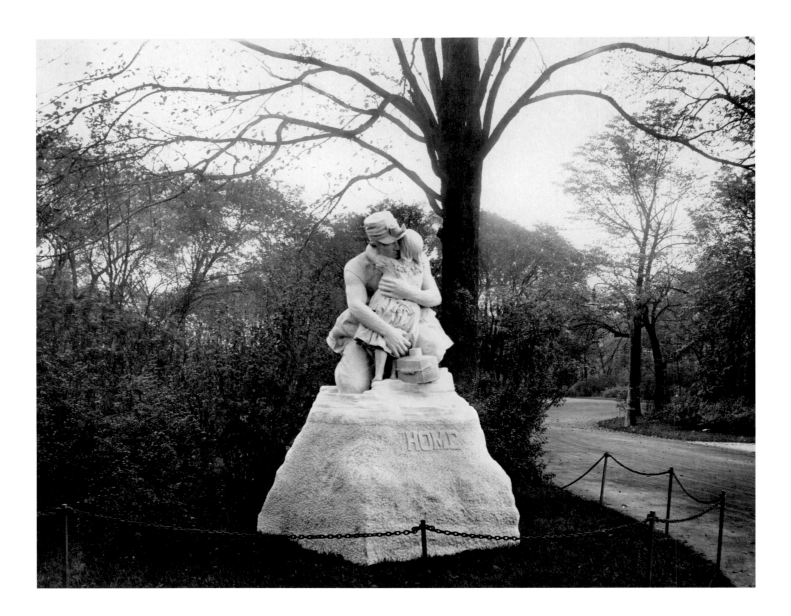

Hearing the suggestion of "Urbs in horto—City in a garden" as a motto must have given Chicago's first residents a good laugh. The young frontier community was hardly a city in 1837 and the onion patch from which it rose was anything but a garden. A rank, swampy smell bore daily evidence of that fact, which explains why *chicago* is an Algonquin word for "onion place."

By all accounts the environs were grim. Out beyond mud lake, somewhere around today's Bridgeport neighborhood, stretched a piece of geography unfamiliar to even the most traveled explorers. It was grass. That's it, just unbelievably tall grass that seemed quite frightening as it stretched to infinity.

What were they thinking? Was it dark humor or wishful daydreaming by souls who felt shipwrecked on the frontier of distant shores, with only green memories of home? Ironic that it would become the most accurate glimpse of Chicago's future.

Gardens, in the form of parks, grew hand in hand with this pioneer town. Before the world's first skyscraper, the 10-story Montauk Building in 1882, or the unrivaled Columbian Exposition in 1893, Chicago's parks suggested a worldly sophistication not usually associated with a boomtown. The question is, Why did this upstart frontier community choose a garden as its motto and declare such an ambitious dream?

My first notion is that these newcomers, of mostly European descent, sought to transport a bit of the old country in an effort to civilize this wilderness. I can hear the land speculators even now, whipping the fever with dreams of building "one of the great cities of the world, filled with promenades 'neath the oaks, just like home." Of course, the truth is that the parks enhanced the real estate values for developers. The combination of "doing good" while "doing well" has driven many a progressive project, and it was an unbeatable partnership that would build a new gateway to the Great Plains and the West. Also, the wisdom of setting aside these green spaces emerged early, in very practical ways. During the Great Chicago Fire of 1871, parks were islands of safety and became temporary havens of shelter for the survivors. And when the temperatures soared within the asphalt and brick wilderness, the parks provided a breeze, a respite.

The "Home" sculpture (also known as "The Miner and His Child") by Charles J. Mulligan was installed in Humboldt Park in 1911, near the entrance at California Avenue and Division Street. (1912. CPDSC.)

Looking back, it's hard to believe that one would have chosen a wetland to site one of the great cities of the world, except for its location linking a waterway from the East to the Gulf of Mexico. And what an attitude! Nature would have to defer to the Manifest Destiny of a new nation. Simply put, Chicago would be built in a swamp and would have to make it work. It wasn't easy. The land oozed with lowland diseases such as malaria, small pox, and cholera. Providing pure drinking water to a growing concentration of people and getting rid of waste was a monumental problem.

During the decade before the Civil War, a cemetery several miles north of the Chicago River became a flash point. Rainwater collecting in newly dug graves spilled out and contaminated the city's drinking supply, which in turn spread disease. After much crusading, 60 acres of the cemetery became Lincoln Park in 1865.

The debate that surrounded the cemetery issue inspired an idea, which would provide a leap forward for the city's magnificent park system. In 1869, a skeletal plan—the bones of a new park system—laid out a network of boulevards to connect parks throughout the city. Much of what we have today can be traced back to that idea. Indeed, consider the growth of the city around three park districts—north, south, and west—and you have the cornerstones of Chicago.

As far back as the 1880s, Lincoln Park became the center of a rich urban life with a zoo, conservatory, sculptures, and lagoons. On the West Side, Garfield, Douglas and Humboldt parks would rival anything in the Old World. And on the South Side, Jackson Park would become the home for the 1893 Colombian Exposition and an extended campus for the University of Chicago. Eventually, the three separate park districts would become one in 1934, and the city would be stronger for it.

Great parks require great landscape architects, and the fingerprints of giants can still be found in living monuments of their work. Trees, paths, lagoons, meadows, and field houses carry the names of Jens Jensen, Frederick Law Olmsted, Alfred Caldwell, and Daniel H. Burnham. But the parks are only spaces. Until people use them, they don't fulfill their role. Their real history is invisible, like the scent from a barbecue that drifts away on the shouts of children on a Sunday afternoon.

How many picnics will be remembered by families as their favorite moments? How many softball games, festivals, concerts, and fireworks displays are etched in their memories? How many children see their first bird, catch their first fish, or take their first hike in a Chicago park?

Perhaps most remarkable in the history of Chicago's parks is the renaissance of recent years that has sparked active refurbishing not seen for decades. Decaying field houses have been restored, statues sparkle again, new

flowerbeds appear and bloom like dormant desert flowers after a rain, and communities are returning to their playgrounds.

The motto "City in a garden" wasn't far off after all. As we've learned, the parks have given us much more than we realize. And they keep on giving. In this new century, temperatures are predicted to rise dramatically along with carbon dioxide, a product of the machines that gave us the Industrial Revolution and Automobile Age. If we didn't have Chicago's parks to cool us off and help absorb the carbon, we would have to create them.

One day when you're strolling the edge of a Jensen-designed prairie lagoon, dodging the geese coming down on a final approach, be sure to thank those first city leaders who could see the day far beyond their time when Chicago would truly be a city in a garden. I know they'll be pleased when they see yet one more park addition, Millennium Park, in a central location downtown. It will prove for all to see that Chicago's parks are second to none in America or the world.

Chicago
5 June 2001

Bill Kurtis is a Chicago-based journalist whose documentay film company specializes in programs about conservation and the environment. He has also worked as a television news anchor and as host of A&E Network series such as *American Justice* and *The New Explorers*. Among the many recognitions his work has garnered is the prestigious George Foster Peabody award. Mr Kurtis serves on the boards of the National Park Foundation, the Chicago Botanic Garden, and the Nature Conservancy, and he is a member of Mayor Daley's Landscape Advisory Task Force and the Calumet Sustainable Growth Advisory Committee. He is also the author of *Bill Kurtis on Assignment* (Rand McNally, 1983).

JULIA

SNIDERMAN

BACHRACH

\mathbf{W}HEN PEOPLE THINK OF THE GREAT PARKS OF AMERICA, images of New York's Central Park or Boston's Emerald Necklace often come to mind. But while Chicago is commonly identified with its role in the development of urban architecture, it can easily be considered as the nation's most influential city of parks.

During the late 1830s, when Chicago's nascent local government adopted the motto, "Urbs in horto," a Latin phrase meaning "City in a garden," there were few green spaces or policies to promote park development. The city's slogan, however, has since proved to be prophetic. For more than 165 years, Chicago's citizens have rallied for the creation and protection of parkland, and the city's parks have long served as a national testing ground for revolutionary ideas, programs, and social reform efforts. Indeed, nearly a quarter of Chicago's existing 555 parks were created or shaped by some of the nation's most significant architects, landscape designers, and artists, such as Frederick Law Olmsted, Daniel H. Burnham, Jens Jensen, Alfred Caldwell, and Lorado Taft.

Origins of an Idea: 1830s–1850s

Several years before the City of Chicago officially incorporated in 1837, the small village began to experience a flurry of land speculation. Native Americans had been pushed west of Chicago, and Fort Dearborn, a military outpost, had been installed some years earlier to protect what was then the nation's westernmost boundary. Speculators were particularly attracted by Chicago's strategic location at the juncture of the Chicago River and Lake Michigan. For years, American Indians and voyageurs traveled from the Mississippi River to Lake Michigan by portaging their canoes through a marshy area between the Des Plaines River and the South Branch of the Chicago River. The federal government sanctioned the construction of a canal to develop this site into a major transportation route. Anticipation of the new canal fostered a surge in the town's population from fewer than 200 in 1832 to 3,265 in 1835.

The Illinois legislature appointed a Board of Canal Commissioners, which began planning for the sale of thousands of acres of land to fund the construction of the Illinois and Michigan Canal. Residents of the fledgling

Washington Park's landscape, designed by Frederick Law Olmsted, featured elegant, naturalistic spaces for relaxation and contemplation. (ca. 1890. CPDSC.)

city began to fear that the sale of land along Chicago's lakefront would lead to commercial and industrial development. Town leaders met on 2 November 1835 to discuss the need to save some of the federally owned lakefront property as open space. Because of this public forum, when sale maps were drawn, the Canal Commissioners labeled two parcels as "public ground." One was west of Michigan Avenue between Randolph and Washington streets, dedicated in 1839 as Dearborn Park (which no longer exists). The other, located between Madison and Randolph streets on the edge of the lake, was marked with the notation "forever to remain vacant of buildings."[1] This grassy strip was transferred to the city during the 1840s and formally dedicated as Lake Park. Although it developed slowly, it would become the first piece of today's Grant Park, now known as Chicago's front yard.

As Chicago experienced rapid growth during the early 1840s, clever real estate speculators began creating small public squares and parks to boost property values in the neighborhoods they developed. Examples include Washington Square, established by the American Land Company in 1842; Goudy Square, by developer H.O. Stone in 1847; and Union Park, by developers Hayes, Johnson, and Baker in 1853.

In 1849, real estate speculator and city booster John S. Wright imagined a much more ambitious scheme of park development that would benefit all of Chicago:

> "I forsee a time, not very distant, when Chicago will need for its fast increasing population a park or
> parks in each division. Of these parks I have a vision. They are improved and connected with a wide
> avenue, extending to and along the lake shore on the north and the south, and surrounding the city with
> a magnificent chain of parks and parkways that have not their equal in the world."[2]

Twenty years later, Wright's idea led to the development of one of the nation's first boulevard systems. At the time, however, the concept did not move forward, and the city continued to purchase and accept donations of land on a piecemeal basis.

Cemetery Conversion and the Early Parks Movement: 1850s–1860s

During the 1850s and 1860s, fears about health and sanitary conditions in Chicago spurred a city-wide parks movement. Alarmed by the high mortality rate in their area, Northsiders worried about the health threat posed by a public cemetery located on the edge of Lake Michigan. Dr. John H. Rauch, a physician who served on the Chicago branch of the National Sanitary Commission, determined that standing water accumulating in newly dug graves flowed into Lake Michigan. Although the city's drinking supply was also contaminated by raw sewage, the

cemetery's contamination of the water contributed to the spread of cholera, small pox, and other diseases. This public health threat soon captured the attention of the entire city. Rauch crusaded to transform the lakefront cemetery into parkland by preparing detailed studies, making presentations to influential organizations, and encouraging prominent citizens to petition Chicago's Common Council. Rauch's campaign met with success in 1860, when the city set aside a 60-acre unused section as Lake Park. Renaming the site shortly after President Abraham Lincoln's assassination in 1865, the city hired landscape gardener Swain Nelson to design and improve Lincoln Park.

As citizens throughout Chicago demanded the complete removal of the cemetery, the issue brought attention to the need for a whole system of new parks. A 15 September 1866 *Chicago Times* article promoted Wright's earlier concept of a network of parks and boulevards to extend along the boundaries of Chicago. Groups of prominent citizens on the North, South, and West sides drafted legislation to realize this ambitious idea. In 1869, the State of Illinois approved three separate acts of legislation establishing the Lincoln, South, and West Park commissions. Although the three park commissions operated independently, the overall goal was to create a unified park and boulevard system that would encircle Chicago.

Lincoln Park: 1869–1900

When the newly formed Lincoln Park Board of Commissioners began meeting in 1869, its first concern was to transform the remaining burial ground on the southern end of the park's new boundaries between Diversey Parkway and North Avenue. Through condemnation proceedings, heirs of the cemetery's lot owners were given a six-month period and compensation to exhume bodies and transfer them to other cemeteries. One family mausoleum, the Couch Tomb (p. 104), was never removed, and it remains a symbol of Lincoln Park's early history.

Landscape gardener Swain Nelson and his then partner Olaf Benson created a plan for the expanded park in 1873. Although their plan initiated the immediate building of Lake Shore Drive, many of their other recommendations proceeded slowly due to funding constraints and legal challenges. As a result of these problems, the Lincoln Park Commission never successfully improved Diversey Parkway as a pleasure drive, and the city's boulevard system ultimately developed in a crescent shape, rather than a full circle.

Between the early 1880s and 1900, Lincoln Park took shape as one of the city's most beautiful and fashionable places. The zoo, which had begun with the donation of mute swans from New York City's Central Park in 1868, had grown to an extensive collection that included polar bears, leopards, a Bengal tiger, African lions, a camel,

Old Lake Shore Drive in Lincoln Park. (ca. 1885. CPDSC.)

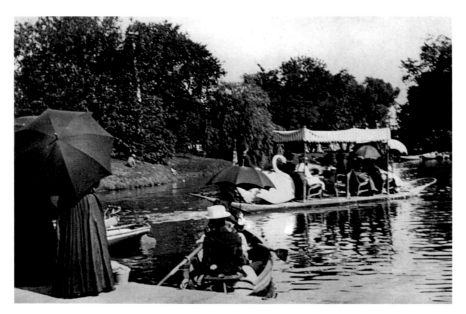

A swan boat and row boat on a lagoon in Lincoln Park. (ca. 1885. CPDSC.)

cemetery's contamination of the water contributed to the spread of cholera, small pox, and other diseases. This public health threat soon captured the attention of the entire city. Rauch crusaded to transform the lakefront cemetery into parkland by preparing detailed studies, making presentations to influential organizations, and encouraging prominent citizens to petition Chicago's Common Council. Rauch's campaign met with success in 1860, when the city set aside a 60-acre unused section as Lake Park. Renaming the site shortly after President Abraham Lincoln's assassination in 1865, the city hired landscape gardener Swain Nelson to design and improve Lincoln Park.

As citizens throughout Chicago demanded the complete removal of the cemetery, the issue brought attention to the need for a whole system of new parks. A 15 September 1866 *Chicago Times* article promoted Wright's earlier concept of a network of parks and boulevards to extend along the boundaries of Chicago. Groups of prominent citizens on the North, South, and West sides drafted legislation to realize this ambitious idea. In 1869, the State of Illinois approved three separate acts of legislation establishing the Lincoln, South, and West Park commissions. Although the three park commissions operated independently, the overall goal was to create a unified park and boulevard system that would encircle Chicago.

Lincoln Park: 1869–1900

When the newly formed Lincoln Park Board of Commissioners began meeting in 1869, its first concern was to transform the remaining burial ground on the southern end of the park's new boundaries between Diversey Parkway and North Avenue. Through condemnation proceedings, heirs of the cemetery's lot owners were given a six-month period and compensation to exhume bodies and transfer them to other cemeteries. One family mausoleum, the Couch Tomb (p. 104), was never removed, and it remains a symbol of Lincoln Park's early history.

Landscape gardener Swain Nelson and his then partner Olaf Benson created a plan for the expanded park in 1873. Although their plan initiated the immediate building of Lake Shore Drive, many of their other recommendations proceeded slowly due to funding constraints and legal challenges. As a result of these problems, the Lincoln Park Commission never successfully improved Diversey Parkway as a pleasure drive, and the city's boulevard system ultimately developed in a crescent shape, rather than a full circle.

Between the early 1880s and 1900, Lincoln Park took shape as one of the city's most beautiful and fashionable places. The zoo, which had begun with the donation of mute swans from New York City's Central Park in 1868, had grown to an extensive collection that included polar bears, leopards, a Bengal tiger, African lions, a camel,

Old Lake Shore Drive in Lincoln Park. (ca. 1885. CPDSC.)

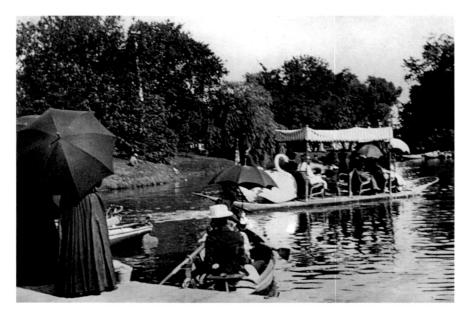

A swan boat and row boat on a lagoon in Lincoln Park. (ca. 1885. CPDSC.)

an elephant, sea lions, and various animal houses and exhibits. The Academy of Sciences's Laflin Building and a Victorian conservatory were also constructed in the park during this period, and the grounds boasted impressive gardens, sculptures, lagoons, and bathing beaches. Problems with lakeshore erosion led to the building of additional breakwaters and the first of many landfill projects that expanded the park's acreage.

South Park System: 1869–1900

The newly appointed South Park commissioners acquired 1,055 acres of land, then located just outside of Chicago's southern border, and hired Frederick Law Olmsted and Calvert Vaux to transform the site into parkland. Having designed New York City's Central Park in 1858, Olmsted and Vaux had become the nation's most influential landscape architectural firm.[3] Olmsted and Vaux believed that urban parks provide not only refuge from the stresses of the city, but also an important social benefit as democratic places where people of all classes can have friendly interactions.

In 1871, Olmsted and Vaux published the plan for South Park, now known as Jackson and Washington parks and the Midway Plaisance. Although they considered the unimproved site extremely bleak, they believed that its relationship with Lake Michigan was its greatest asset.[4] Their compositions often combined sublime elements such as a shadowy winding path, which created a sense of mystery or anxiety, with beautiful or graceful elements such as a broad sunny meadow, which made people feel calm. Interpreting the lake as a tremendous object of sublime scenery, Olmsted and Vaux used water as the plan's guiding theme. They designed a rugged series of lagoons linking Lake Michigan on the east with Washington Park on the west via a long canal through

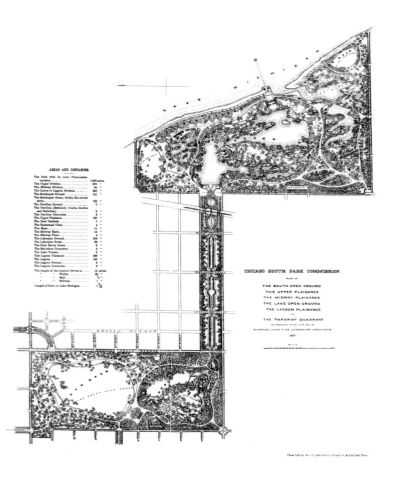

The plan of South Park (now Jackson and Washington parks and the Midway Plaisance). (Olmsted, Vaux & Co., 1871. CPDSC.)

the middle of Midway Plaisance. In Washington Park, the firm created the element that best conveyed their beautiful style, the South Open Green, a meadow for ball games, in which sheep freely roamed.

By the late 1880s, most of Washington Park comprised an improved landscape, but only the northernmost part of Jackson Park's marshy site had been transformed into parkland. After a local committee secured Chicago as the site for a major World's Fair in 1890, Frederick Law Olmsted was asked to help select the fair's location. Stressing the importance of views of Lake Michigan as the fairground's backdrop, and noting the unfinished state of Jackson Park, he suggested this as the site for the World's Columbian Exposition. Along with renowned architects Daniel H. Burnham and John Wellborn Root, Olmsted and his assistant, Henry Codman, planned a gleaming campus of monumental buildings set in a landscape of interconnected lagoons, oriented around the formal Court of Honor basin. Visitors entering the fair by train or boat saw this ceremonial water court and its linkage to Lake Michigan upon their arrival. Just to the north, the Court of Honor linked naturalistic lagoons surrounding large Wooded Island with smaller islands scattered around its edges.

Olmsted intended Wooded Island as a refuge from the densely built and classically inspired structures of the "White City," created by a team of the nation's most important architects and sculptors. To produce sylvan character, Olmsted re-shaped a natural, sandy bar peninsula into an island, retaining the site's stands of native oak trees. He also transplanted masses of shrubs and aquatic plants from marshland in Illinois and Wisconsin to Wooded Island and around its edges. Although Olmsted had hoped to keep the island free of buildings, there were many requests to build there. The only structure that Olmsted agreed to was the Japanese pavilion. He felt that this simple and elegant ancient Japanese temple, known as Ho-o-den, would not interfere with the natural appearance of the island.

During a six-month period in 1893, Jackson Park's World Columbian Exposition dazzled more than 27 million visitors. After the fair, a series of fires destroyed many of the buildings, and most of the other structures

A bird's-eye view of the grounds of the World's Columbian Exhibition in Chicago, 1893. (From the Book of the Fair, *1895, p. 577.)*

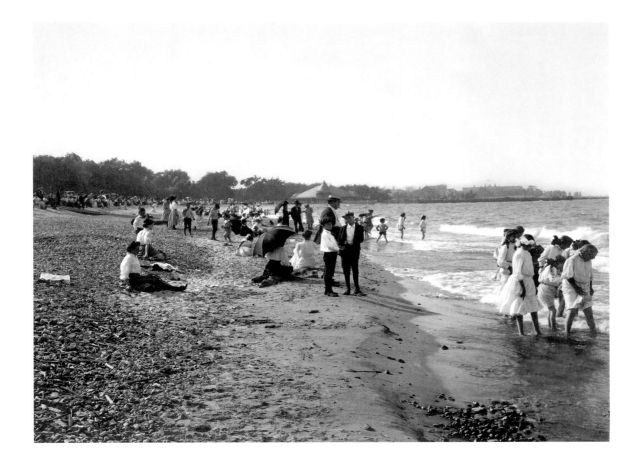

The beach at Jackson Park.

(ca. 1900. CPDSC.)

were soon razed. In 1895, Olmsted's firm, then known as Olmsted, Olmsted, and Eliot, began transforming the site back into parkland. Remaining true to the park's original plan, the re-design included an interconnected system of serene lagoons with lushly planted shores, islands, and peninsulas. A magnificent promenade, now part of Lake Shore Drive, provided broad views of Lake Michigan. In contrast to the sublime views of the water, the plan also incorporated an elongated meadow for lawn tennis and a larger playing field. In 1899, the South Park Commission used the long meadow as the site for the first public golf course in the Midwest, and the following year the playing field was adapted for use as an 18-hole course that still exists today.

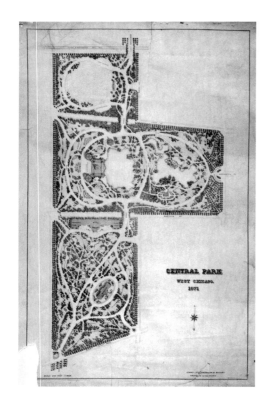

*Jenney's plan of Central
Park (now Garfield Park).
(1871. CPDSC.)*

RIGHT:

*A view of the northeast
corner of Douglas Park.
(1872. CPDSC.)*

West Park System: 1869–1900

Originally known as North, Central, and South parks, the West Park System later became known as Humboldt, Garfield, and Douglas parks, with interlinking boulevards. Plans for the entire ensemble were completed in 1871 by William Le Baron Jenney, an architect, engineer, and landscape designer best known for contributions to the development of the skyscaper. Jenney had studied engineering in Paris during the 1850s, and later served along with Frederick Law Olmsted to improve sanitary conditions during the American Civil War. Jenney's plans for the three west parks incorporated features characteristic of Olmsted's work such as picturesque lagoons, winding paths, open meadows, and lushly planted areas. In addition to Olmsted's influence, Jenney's plans made references to French landscapes through elements such as formal esplanades, ellipses, terraces, and pavilions.

The unimproved West Park sites were flat, swampy, and dreary. According to Jenney, the natural landscapes did not present "a single suggestion for the design of the future park," and "lacked a single tree worthy of preservation."[5] Jenney relied on his engineering expertise to address these difficult site conditions. The Douglas Park site was so swampy that Jenney had truckloads of sand and manure brought in from the Chicago Stock Yards to amend the soil. In addition, Jenney included a lagoon in each of the three park plans not only to provide beautiful scenery, but also to function as reservoirs, helping to alleviate drainage problems in marshy areas.

Due to budget constraints, the West Park Commission built the parks in phases, and Jenney's plans were only partially realized. Despite the slow pace, by 1877 each of the three sites had officially opened some acreage to the public. By the early 1880s, Humboldt, Garfield, and Douglas parks each had lawns, trees, winding paths, rustic pavilions, benches, a small conservatory, and a lagoon with row boats available for park patrons.

In 1885, Danish immigrant Jens Jensen, now recognized as dean of the Prairie style in landscape architecture and leader of the Midwestern conservation movement, began working as a laborer for the West Park Commission. Soon promoted to foreman, Jensen laid out a formal garden with exotic plants and was "quite proud of it."[6] In 1888, however, after observing that "foreign plants didn't take kindly to our Chicago soil," he "went out into the woods with a team and wagon," carting in wildflowers and transplanting them in Union Park, then the West Park System's headquarters.[7] Although few park visitors had seen a wildflower garden before, Jensen's *American Garden* became quite popular (p. 152). Working his way up through the park system, Jensen became superintendent of Humboldt Park in 1895. Unfortunately, the Park Commission was then entrenched in corruption. After refusing to participate in political graft, Jensen was fired for the first time in 1900.

Progressive Era: 1900–1920

By the late 1890s, it had become apparent that the existing parks could no longer satisfy the needs of the Chicago's growing population. The city's tremendous industrial expansion had enticed vast numbers of European immigrants to settle here. By 1900, nearly 750,000 people, almost half of Chicago's population, resided in the central part of the city, more than a mile away from any park. At that time, there were 846 city residents per acre of parkland.[8] Living and working conditions were intolerable, and in order to survive many immigrant families had to put their children to work. If children were lucky enough to have time off, there were few clean or safe places in which to play.

In 1898, reformer and photojournalist Jacob A. Riis, of New York City, addressed this issue at a meeting of the Municipal Science Club held at Hull House, Jane Addam's influential settlement house in Chicago. Focusing

on the need for additional breathing spaces in Chicago's tenement districts, the club inspired the creation of a Special Park Commission by Mayor Carter Harrison the following year. Early commission members included social reformers Graham Taylor and Charles Zueblin, businessman Clarence Buckingham, Prairie School architect Dwight H. Perkins, and landscape architects Jens Jensen and Ossian Cole Simonds. The Special Park Commission sought to study Chicago's existing open spaces, create playgrounds in the city's most densely populated neighborhoods, and develop a systematic plan for parks and recreational areas throughout the metropolitan area. Over a one-year period, Jensen and his friend and colleague, Perkins, conducted an exhaustive study, recommending a whole series of new parks and playgrounds and the protection of thousands of acres of forests, prairie, and marshland. Jensen and Perkins's influential report, published in 1904, led to the formation of the Forest Preserve District of Cook County a decade later.

The Special Park Commission at first created municipal playgrounds in the city's most densely populated neighborhoods. A major budget reduction in its second year, however, severely limited the commission's ability to acquire and improve land. In response, the agency began working cooperatively with the Board of Education and the three park commissions in order to achieve its goals. The Special Park Commission inspired the creation of the playgrounds on public school property. It also drafted state bills to allow the South, West, and Lincoln Park commissions to establish new parks for the first time since 1869. The South Park Commission took the lead, acquiring a site near the stockyards and opening experimental McKinley Park in 1902. Providing ballfields within a beautiful landscape, the new park also introduced features that had not previously existed in the South Park System, such as a playground, swimming lagoon, and changing rooms (p. 118). In July of 1902, more than 10,000 people attended McKinley Park's dedication ceremonies, and the new site gained immediate popularity.

Revolutionary South Side Parks: 1905
McKinley Park's success inspired the South Park Commission to initiate a system of neighborhood parks that would provide breathing space and social services to tenement neighborhoods throughout the district. South Park Superintendent J. Frank Foster conceived of a variety of features that would be included in the new parks such as outdoor gymnasiums for men and women, children's wading pools and sand courts, and a new type of building, the field house, which would provide athletic, educational, and recreational programs throughout an entire year. Foster commissioned Frederick Law Olmsted's successors, the Olmsted Brothers, as landscape architects and the D.H. Burnham & Company architectural firm to design 14 neighborhood parks for Chicago's South Side.

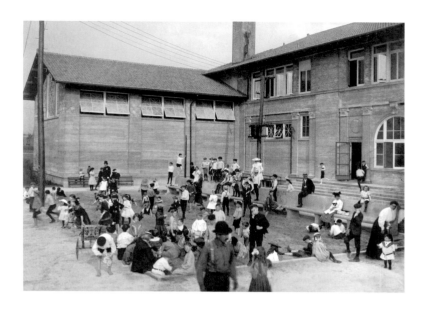

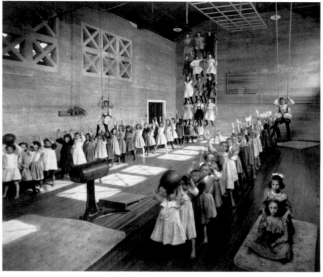

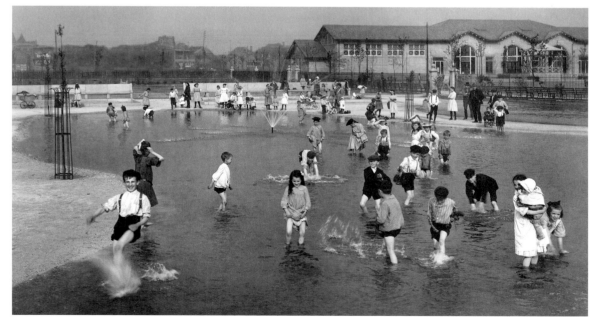

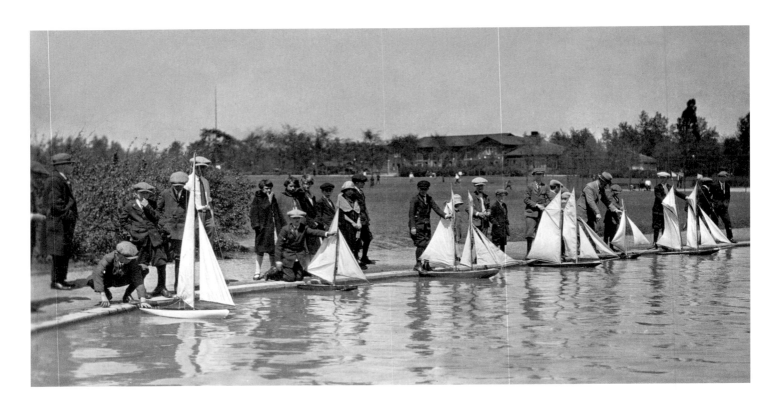

Although every plan incorporated similar features and basically followed a prototypical scheme, the Olmsted Brothers believed it important to give each park its own individual design. Similarly, Edward H. Bennett, of D.H. Burnham & Company, drew influence from the classicism of the World's Columbian Exposition, and created a uniquely designed architectural complex for each park.

Among the first 10 new sites, which opened to the public in 1905, were Mark White Square (now known as McGuane Park) and Ogden, Sherman, and Hamilton parks. An array of innovative programs and facilities were provided in these parks, including the earliest branches of the Chicago Public Library, English lessons, inexpensive hot meals, free public bathing facilities, and health services. The 10 new parks proved so successful that President Theodore Roosevelt proclaimed them "the most notable civic achievement in any American city." [9]

Reform and Innovation in the West Park System: 1905–1920

As the pioneering neighborhood parks began offering new amenities to the city's South Side, improvements were finally underway within the West Park System. In 1905, a reform-minded governor, Charles S. Deneen, swept the commission clean, appointing an entirely new and progressive board that selected Jens Jensen as its general superintendent and chief landscape architect. Inheriting a neglected and deteriorated park system, Jensen began ambitious improvements to Humboldt, Garfield, and Douglas parks. These projects gave Jensen an opportunity to experiment with his evolving naturalistic style such as demolishing poorly maintained small conservatories in all three parks in order to construct the larger, centralized Garfield Park Conservatory (pp. 62, 64, and 65).

The new Garfield Park Conservatory was considered revolutionary when it opened in 1908. Unlike other conservatories of the period, the structure's form was meant to emulate a haystack and the interior was conceived as landscape art under glass.[10] Many other conservatories had showy displays of plants in pots on pedestals or in large groupings in the center of a room. Jensen, however, placed plants directly in the ground and framed views by keeping the center of each room open, with a fountain or a naturalistic pond serving as the centerpiece. He also hid exposed pipes and mechanical systems by tucking them behind beautiful walls of stratified stonework. Unlike the mounds of volcanic stone used in Victorian conservatories, Jensen's horizontal stonework resembled the bluffs and outcroppings found along rivers in the Midwest.

Unfinished areas within all three parks also gave Jensen the opportunity to create impressive naturalistic landscapes. He established horizontal meadows edged with masses of native trees and shrubs that offered broad views of the landscape and provided space for lawn tennis, baseball, and festivals. In Humboldt Park, Jensen extended the

Proposed improvements in Humboldt Park, including Jensen's formal, circular rose garden. (ca. 1906. CPDSC.)

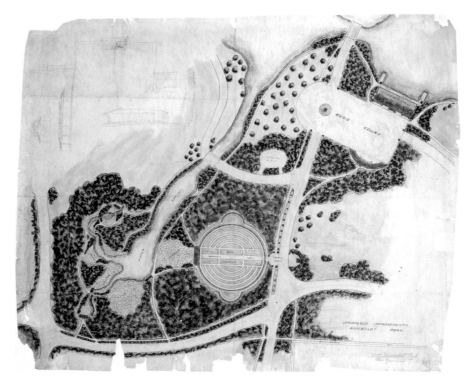

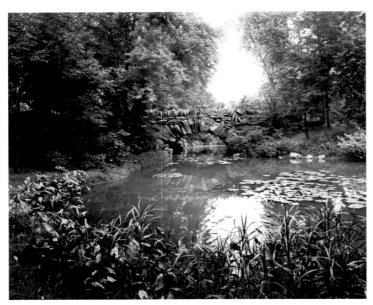

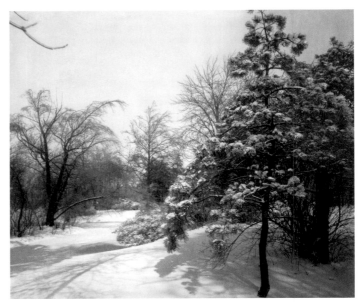

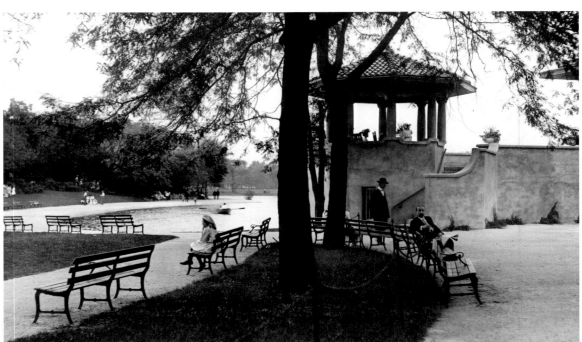

park's existing lagoon into a long, meandering waterway evocative of the natural scenery he saw during trips to wetland areas in Illinois and Wisconsin (p. 80). Nearby he created a formal circular rose garden and adjacent perennial garden that incorporated wildflowers and ornamental native grasses (pp. 82 and 83). Similarly, Jensen introduced formal gardens in Douglas and Garfield parks that deviated from tradition by including native plants and Prairie style architectural elements. Jensen believed that "every detail of the park composition should be in absolute harmony," and he was particularly interested in the placement of sculpture in the landscape.[11] Under the auspices of the Municipal Art League, Jensen sponsored outdoor art exhibitions in Humboldt and Garfield parks in 1908 and 1909, in which he placed sculptural works in appropriate settings.

Visitors in their finery at the stepping stone path in Humboldt Park. (1911. CPDSC.)

The new neighborhood parks on Chicago's South Side inspired the West Park commissioners, and in 1907 Jensen had the opportunity to create similar parks for their district. Due to the West Side's extreme density, the commissioners could only acquire very small sites. Despite this, Jensen included all of the major program components introduced by the South Park prototype, incorporating Prairie style field houses and site furnishings, and some native plantings. He also created small clearings for free play, as well as community gardens, in which gardeners taught children how to plant and tend their own plots.

Jensen also explored other ways to bring people closer to nature. Embracing a connection between nature and the performing arts, Jensen encouraged outdoor performances and festivals, such as a major event held in Garfield Park in 1915. This *Pageant of the Year and Play Festival* celebrated the four seasons. A procession of 1,400 children and adults in costumes representing flocks of birds, trees, flowers, and other natural features paraded before an audience of 25,000.[12] Jensen's interest in the performing arts also prompted him to include natural looking outdoor theaters, called players' greens, in several park plans (p. 53).

Due to changing political tides, Jensen shifted his role from superintendent to consulting landscape architect in 1909. Despite this change, he continued to make ambitious recommendations and create visionary designs. In

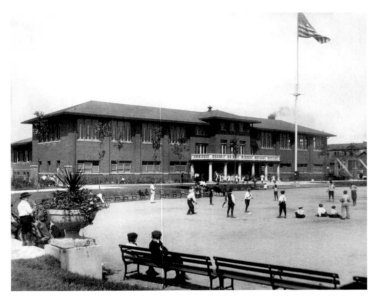

TOP LEFT

*Dvorak Park's ball field
and field house.
(ca. 1912. CPDSC.)*

TOP RIGHT

*Public bathing facilities at
Eckhart Park.
(1908. CPDSC.)*

RIGHT

*Harrison Park's
community gardens. (1921.
CPDSC.)*

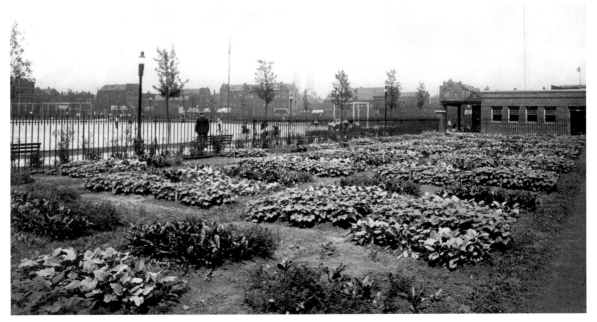

1917, Jensen began an intensive study, suggesting the addition of thousands of acres of new parks, boulevards, greenways, and gardens to the West Park System. Although little of this *Plan for a Greater West Park System* was ever implemented, one of its recommendations, a new large park at the western limit of Chicago, was realized. This was Columbus Park, Jensen's first and only opportunity to design an entirely new large park for Chicago. Jensen considered Columbus Park as "complete an interpretation of the native landscape as anything" he had ever done.[13] Unfortunately, in 1920, while the park was under construction, Jensen lost political support once again, and he severed his ties with the West Park Commission for the final time.

Lincoln Park Expands: 1900–1920

Like the West Park System, the Lincoln Park Commission also experienced a period of political reform during the early twentieth century when Bryan Lathrop, a prominent real estate speculator and philanthropist, was appointed to its Board of Commissioners. Lathrop was the nephew of Thomas Barbour Bryan, founder of Chicago's Graceland Cemetery, one of the nation's premier naturalistic landscapes. As a member of Graceland Cemetery's board, Lathrop became mentor to landscape gardener Ossian Cole Simonds. There he encouraged Simonds to bring innovative approaches to designing and managing the cemetery landscape, which included transplanting native vegetation from the countryside as early as 1880. Lathrop recuited Simonds to serve as the Lincoln Park System's consulting landscape gardener in 1903.

Simonds soon began a major landfill addition to Lincoln Park. Adding 275 new acres of land, the project nearly doubled Lincoln Park's size (p. 111). It was seen as the first step towards a larger ambition of adding a total of five miles of new acreage to Lincoln Park's northern shoreline. In addition to park expansion, Simonds also redesigned some of the park's older sections. The intent was to accommodate recreational programs while also producing "the quiet sylvan conditions so much needed and desired by city dwellers."[14] This was achieved by elongating some of the park's tightly winding paths, and screening architecture and views of busy streets. Simonds attempted to camouflage buildings with plantings, even though many were rendered in the Prairie style and designed by his colleague, Dwight H. Perkins.

As the commission worked on expanding Lincoln Park, it also began efforts to create neighborhood parks in 1907. Between the following year and 1920, the Lincoln Park Commission completed seven new parks, naming them for the members of Abraham Lincoln's cabinet, such as Salmon Chase, William Seward, and Gideon Welles. Although these were inspired by the work of the South and West Park commissions, due to funding restrictions they tended to be more modest in design and programming.

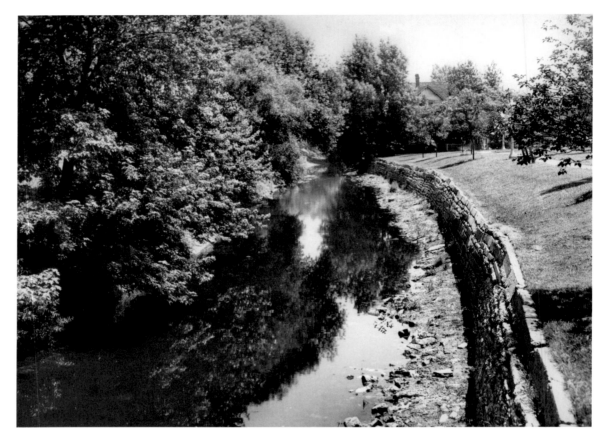

Geographic Expansion Leads to Additional Parks: 1895–1930s

As early real estate speculators had predicted, by the 1890s Chicago's ribbon of parks and boulevards no longer bordered the city. Since the creation of the three park commissions in 1869, Chicago's boundaries had pushed north, south, and west. The city experienced tremendous expansion in June of 1889, when residents of many surrounding townships and unincorporated areas voted in favor of annexation to Chicago. At that time, the city had grown from 43 to 169 square miles in size. Because these new areas were not within the jurisdictions of the South, West, or Lincoln Park commissions, in 1895 the state approved an act allowing voters within these unserved communities to create their own park districts.

In 1896 and 1900, the first two newly annexed areas to take advantage of the act established the North Shore and Ridge Avenue park districts. Located on Chicago's far North Side, these park districts formed primarily to improve roads and boulevards. Some of the other annexed communities had existing parks, and districts were soon created to improve and maintain them. The greatest impetus for new districts, however, was the South Park Commission's influential neighborhood park system. Although many of the newly added communities were more affluent than the tenement districts for the which the prototype had been conceived, residents of neighborhoods throughout the city wanted similar amenities.

A number of districts formed in neighborhoods along the North and South branches of the Chicago River, where park development helped suppress commercial encroachment. Here, landscape improvements in parks such as Eugene Field, River, and Gompers (p. 68) could take advantage of the sites' natural attributes. Similarly, some districts had the advantage of great stands of pre-settlement trees, such as those in West Pullman Park.

Many of the new districts had limited financial resources because of their small taxing jurisdictions. Therefore, land acquisition and improvements occurred in stages, often over a long period of time. Despite budgetary constraints, most of the new park boards constructed field houses, and the attractive bungalows and apartment buildings within the surrounding neighborhoods often influenced their design. Many park boards hired Clarence Hatzfeld, an architect responsible for residences, banks, and other commercial buildings in these neighborhoods. Among more than 20 brick Prairie and Revival style field houses designed by Hatzfeld during the 1910s and 1920s are elegant buildings in Portage (p. 128) and Indian Boundary (p. 88) parks.

As the parks in the new districts developed, they soon came to be seen as valuable amenities of good Chicago neighborhoods rather than as vehicles of social reform. Many residents of these neighborhoods had their own yards, and thus were not in dire need of breathing space, as had been the case in the tenement districts. Rather, they primarily wanted neighborhood parks for organized sports, club and social activities, and hobbies. By 1930, 19 new park districts had been formed, resulting in a total of 22 independent agencies operating simultaneously in Chicago.

Lakefront Development: 1890s–1930s

While Chicago's neighborhoods were developing, the downtown lakefront received attention. After transforming wind-swept, sandy Jackson Park into the glistening World's Columbian Exposition of 1893, Daniel H. Burnham began to envision Grant Park as a lovely campus of civic and cultural buildings with the Field

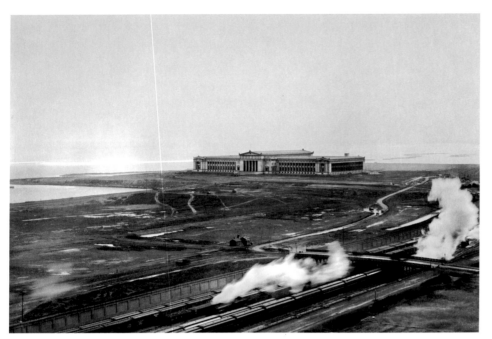

Museum of Natural History as its center-piece. He also began sketching a magnificent linear lakefront park and boulevard that would link Grant Park with Jackson Park, the site of the World's Fair. These extraordinary ideas were incorporated into Burnham and Bennett's seminal 1909 *Plan of Chicago*.

Although the South Park Commission took immediate action to realize Burnham's ambitious plans, significant factors delayed progress. For years, Grant Park was little more than a dumping ground with garbage heaps and squatters' shacks along an unfinished stretch of landfill. Mail order magnate Aaron Montgomery Ward, whose offices were located across the street on Michigan Avenue, filed a series of lawsuits relating to Grant Park.

The landfill and Field Museum of Natural History at the south end of Grant Park.

(ca. 1920. CPDSC.)

Initially, Ward had only hoped to improve the park's unsightly appearance. When Burnham's plans were announced, however, Ward focused his attention on the need to protect the lakefront as open space. Due to the early restrictions placed on development, the State Supreme Court ruled in Ward's favor, prohibiting construction of the Field Museum in the center of Grant Park in 1911. Later that year, the South Park Commission negotiated with the Illinois Central Railroad to acquire riparian rights south of the existing park. By gaining these rights, the commission was able to begin landfill operations to expand Grant Park to the south, creating an alternate site for the museum.

The South Park Commission's agreement also made way for Burnham's scheme to create a new linear park of human-made islands, a boat harbor, bathing beaches, meadows, and playfields, extending from Grant to Jackson parks. Before any work could proceed, however, many other legal matters had to be settled. For example, there were various lawsuits between park interests and other lakefront property owners, and government agencies at every level, including the Secretary of War, had to approve the plans. In 1920, consent of all parties was finally secured,

and voters approved a $20 million bond issue to finance the project. Landfill operations began at the northern end of the new park, and by 1925 new landforms were constructed as far south as 23rd Street. With work on the mainland progressing and Northerly Island taking shape, the South Park commissioners officially named the entire site in honor of Daniel H. Burnham in 1927.

The proximity of Burnham Park to museums, newly constructed Soldier Field, good transportation, and dramatic lakefront views all made it an ideal location for Chicago's second world's fair in 1933–1934. General Charles S. Dawes, then Vice President of the United States, spearheaded the organizing committee and suggested that the entire fair be privately financed. The World's Fair organization conducted an extremely successful campaign, raising the necessary funds in the midst of the Great Depression. As landfill operations were underway, architect Edward H. Bennett, who had previously designed buildings for the South Park Commission as a member of D.H. Burnham & Company, began laying out the plan for the fair.

Entitled *A Century of Progress*, the fair celebrated "the progress of civilization during the hundred years of Chicago's existence."[15] This theme, the fair's gleaming asymmetrical campus of Art Deco style buildings, and its focus on technological advances gave visitors a sense of

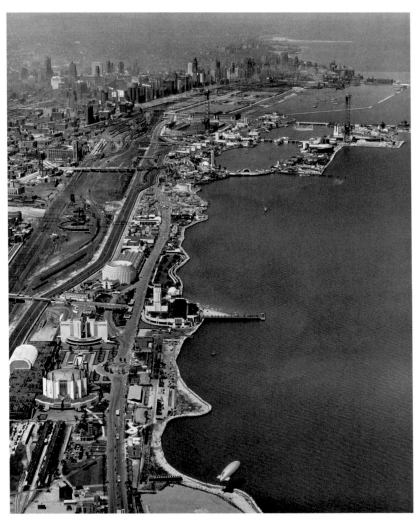

hopefulness and pride during the difficult Depression years. In addition to museum and corporate exhibits, the fair featured attractions such as the "Sky Ride," with double-decker rocket cars running along cables between two giant towers, and "Wings of a Century," highlighting the century's advances in transportation from stage coaches to airplanes. Foreign governments participated by creating "Streets of Paris," the "Black Forest Village," and other

The Century of Progress *Fair in Burnham Park.*
(21 June 1934. CPDSC.)

replicas of famous places. The Midway offered exotic and bizarre exhibits, including the "Odditorium" and "Ripley's Believe It Or Not." Most popular of the fair, however, was the risqué fan dancer, Sally Rand. *A Century of Progress* boasted 82 miles of spectacles, rides, and exhibits, attracting more than 38 million visitors for two full seasons in 1933 and 1934.

Chicago Park District: 1934–1940s

By 1934, all of Chicago's 22 independent park districts were rendered financially insolvent due to the Great Depression. Eighteen of the districts had defaulted on their bonded indebtedness, nine were behind in paying employees' salaries, and all owed money to contractors and suppliers.[16] For years, there were discussions about the inefficiency of having so many separate agencies providing recreational services and managing Chicago's parks. To reduce duplication of services, streamline operations, and gain access to funding through President Franklin Delano Roosevelt's New Deal, voters approved the Park Consolidation Act of 1934, which established the Chicago Park District (CPD).

Chicago's Mayor Edward J. Kelly, who had recently served as the president of the South Park Commission, was well versed in parks administration, and he helped to set up the large, new organization. Several board members and most of the department and division heads had served similar positions for the independent park districts. Between 1935 and 1941, the newly consolidated CPD received $82 million in federal funding through the Works Progress Administration (WPA). State and city funds increased this total to more than $100 million. At the time of consolidation, the Chicago Park District inherited more than 130 parks, including 83 field houses, 13 beaches, five golf courses, and 50 swimming pools. As these park facilities and landscapes were in various states of completion and disrepair, a significant portion of WPA funds allowed a flurry of construction and improvement projects.

Chicago Park District staff members were responsible for most of the planning, engineering, design, and construction work. Although pressure to build quickly resulted in some poorly conceived and executed projects, many notable works of architecture and landscape design emerged during this period. Among them were the North Avenue Beach House, designed to emulate a lake ship, and a series of rustic, masonry

Constructing the lagoon, designed by Alfred Caldwell, at Riis Park. (ca. 1936. CPDSC.)

and brick revival style shelter buildings and comfort stations. Remarkable landscape architecture of the 1930s includes the work of Alfred Caldwell, a disciple of Jens Jensen. In addition to designing landscapes for expansive landfill additions to Lincoln and Burnham parks, Caldwell re-designed Lincoln Park's lily pool (p. 109), and completed the western side of Riis Park (p. 138). Caldwell's naturalistic style and use of native plants profoundly influenced other in-house landscape architects.

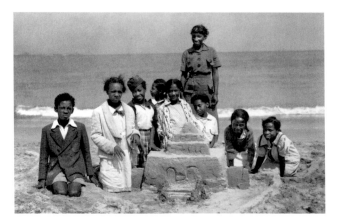

Children participate in a sand castle contest on the lakefront. (ca. 1935. CPDSC.)

Using WPA funds, the Park District also provided a broad array of recreational, educational, and arts programs. A large menu of athletic programs, competitions, and contests included canoe racing, kite tournaments, fencing, water polo, tumbling, and baseball schools. Examples of arts initiatives were the founding of the Grant Park Concerts in 1935 (p. 72) and an Art Department headquartered in Washington Park, which employed 350 painters, illustrators, sculptors, and art teachers. Park patrons could also participate in drama classes, theater and dance guilds, music lessons, and concerts. Among

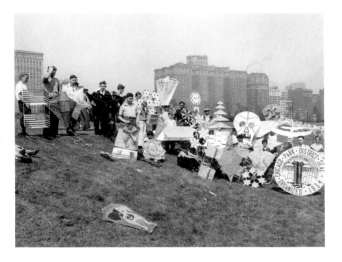

A kite tournament in Grant Park. (9 May 1936. CPDSC.)

the crafts offerings were model airplane and yacht making, marbles, and automobile reconditioning. Toys made in adult wood craft classes were placed in toy-lending libraries and used by CPD play groups. Giant water floats produced by the craft classes were placed in Burnham Park Harbor, illuminated, and paraded on summer nights in the *Carnival of the Lakes*. Many efforts were made to reach out to women and to minority groups, including African-Americans, and the district began to hire a diverse work force during this period.

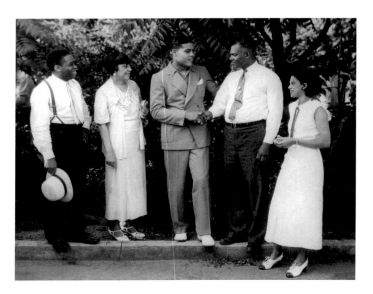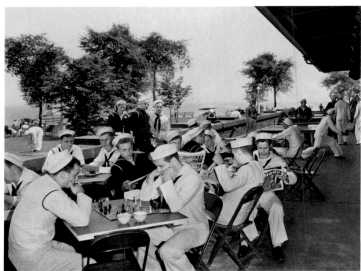

By the end of 1941, WPA funding had been eliminated, and the Park District's focus shifted to the war effort. Every member of the recreation staff was given Red Cross training, and each of the then existing 96 field houses offered similar training to the public. Park District employees participated in a civilian defense organization, and mass meetings were held in various field houses. Neighborhood residents planted victory gardens in many parks. In Lincoln Park, the old Daily News Sanitarium for Sick Babies was converted into a recreation center for the United Service Organization (USO). The CPD began to hire women for previously restricted positions such as lifeguards and service guards to help the park police.

Post-War Expansion: 1945–1960

Shortly after World War II, the CPD began a major initiative to create new parks that would serve the city's booming population. Identifying neighborhoods with few recreational facilities and rapidly growing undeveloped areas, the Park District selected 43 sites for new parks as part of a *Ten Year Plan*. The effort also included an extensive program to build field houses, swimming and wading pools, playgrounds, and athletic equipment in the existing parks. By the late 1940s, the expansion program included a School-Park Plan, a cooperative effort between the

Chicago Park District and the Board of Education. By creating parks on land adjacent to new schools, the facilities could be used by school children during the day and the public during evenings and weekends. During the early 1950s, the CPD began a similar program with the Chicago Housing Authority, through which new parks were built in conjunction with housing projects.

A 1952 bond issue funded the completion of many of the projects conceived in the *Ten Year Plan*, as well as a major reconstruction of South Lake Shore Drive and several other improvements to boulevards. To eliminate the inefficiency of both the Park District and City of Chicago maintaining large areas of roadway and parkland, the two agencies entered into a consolidation agreement in 1959. Through this merger, the city assumed management of the boulevards and transferred control of more than 250 municipal parks, playlots, natatoriums, and beaches to the CPD. The park police force also merged with the Chicago Police Department.

Rise of Active Recreation: 1960–1970s

During the early 1960s, President John F. Kennedy's administration initiated a national physical fitness campaign, and as Americans became increasingly concerned with athletics the CPD placed greater emphasis on recreational programs. In 1964, nearly 3 million people used Park District pools and 14,000 children participated in Learn-to-Swim programs. At that time, there were over 4,000 organized softball teams, 1,400 baseball teams, 1,500 basketball teams, and more than 600,000 people who played tennis in Chicago's parks.

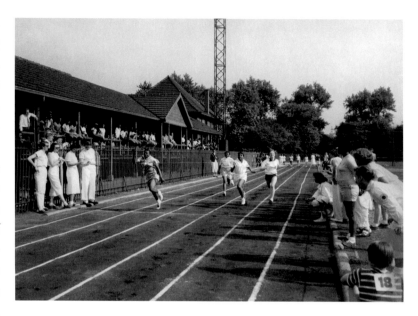

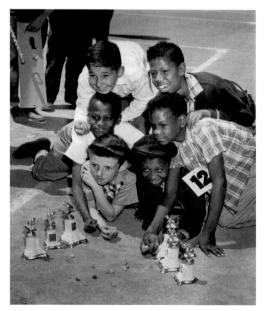

ABOVE

A racially integrated girls' track meet in Douglas Park. (1957. CPDSC.)

LEFT

Winners of the Chicago Park District's city-wide marbles tournament in Garfield Park. (April, 1958. CPDSC.)

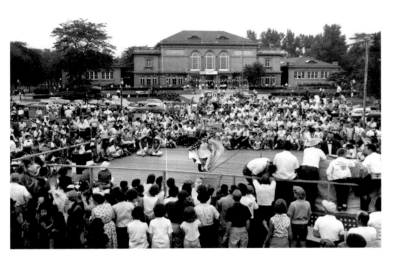

A Labor Day event in Calumet Park celebrates ethnic diversity in one of Chicago's earliest Mexican communities. (September, 1962. CPDSC.)

Two years later, annual attendance for the Park District's 104 day camps totaled more than 16,000 children.

By the late 1960s, programming for diverse populations became a growing concern. Senior citizens' programs were expanded. Cooperatively with other agencies, the Park District began providing programs for the physically and developmentally challenged, including blind children, persons with multiple sclerosis, paralysis, and other disabilities. In 1968, the CPD hosted the First International Special Olympics Games at Soldier Field. Organized by the late president's sister, Eunice Kennedy Shriver, this program gained tremendous success, and now includes participants throughout 150 nations each year.

A major construction program during the early 1970s produced several new field houses and swimming pools and the McFetridge Sports Center with its regulation sized ice skating rink and indoor tennis courts. In 1972, the United States Olympic swimming trials were held in the reconstructed pool in Portage Park (p. 130). Four years later, CPD replaced a huge surface parking lot in Grant Park with the Richard J. Daley Bicentennial Plaza. This facility incorporates underground parking with a major indoor and outdoor recreational complex.

Citizens Inspire Park Reform: 1970s–1980s

By the early 1970s, as citizens became concerned about proposed alterations and the overall management of Chicago's parks, a new era of activism began. Several years earlier, when construction crews started cutting down trees to make way for a major roadway extension through Jackson Park, Southsiders chained themselves to trees. Construction of buildings along the lakefront drew growing public outcry. As a result of these criticisms, the city adopted the Lake Michigan and Chicago Lakefront Protection Ordinance in 1973 (p. 167).

Throughout the decade, citizens complained that a political patronage system produced an unqualified and incompetent park work force, that parks in minority neighborhoods were overlooked, that programs were poorly developed, promoted, and unreliable, and that facilities and landscapes were neglected and rapidly deteriorating.

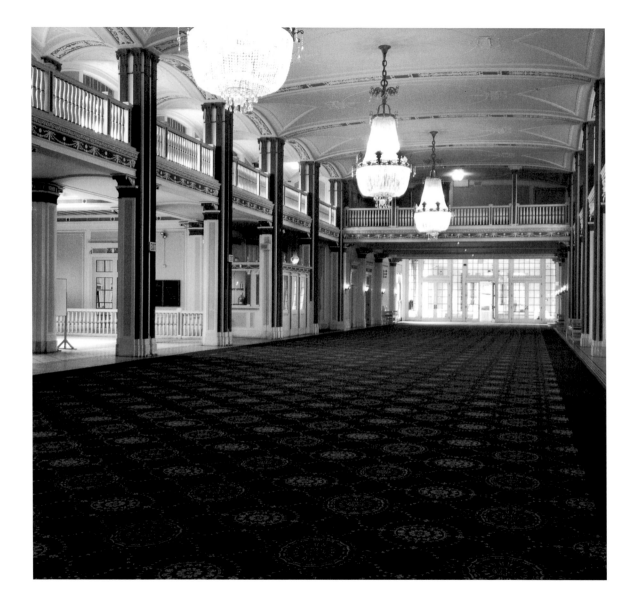

The interior hallway of the restored South Shore Cultural Center. (Summer, 2000. J.I.)

In 1974, after *Chicago Tribune* writer, Jory Graham, published an article entitled, "A Slow Death for the Parks," in *The Chicagoan*, a group of concerned citizens responded by forming the Friends of the Parks.[17] At the same time, a group organized after the CPD announced plans to demolish the historic South Shore Country Club building. Having acquired the recently defunct 65-acre private club to expand its lakefront holdings, the Park District planned to raze the elegant facility. An angry coalition quickly formed and convinced the CPD to rescind this decision.

In 1982, a group of citizens and civic groups filed a formal complaint against the CPD with the United States District Court. This document asserted that the Park District's policies and practices discriminated against residents of Chicago's African-American and Latino communities "in the supply, distribution, and maintenance of recreational services, programs and facilities."[18] The following year, the dispute was settled through a consent decree. The CPD formed a task force, which undertook an exhaustive study and issued a series of recommendations in 1987. This effort resulted in a plan to decentralize management of the parks, divide resources and staffing in an equitable manner, undertake landscape and facility rehabilitation projects, and adopt a system of citizen-based advisory councils to review Park District plans, policies, and operations. By the late 1980s, many of these reforms had begun. Among many new initiatives, the CPD rehabilitated 500 deteriorated park playlots over a five-year period. A major reforestation effort and a series of architectural projects were conducted, including the restoration of the South Shore Country Club facility (now known as the South Shore Cultural Center) and Café Brauer in Lincoln Park (p. 108). The discovery of thousands of archival plans, drawings, and photographs in a sub-basement vault beneath Soldier Field helped to bolster restoration efforts.

New Era: 1990–21st Century

The election of Mayor Richard M. Daley in 1989 marked a new era of greening, improving, expanding, and updating Chicago's parks. Among the Park District's goals were replanting degraded park landscapes, creating hundreds of gardens and several new natural areas, rehabilitating dozens of park structures, constructing new field houses, beach houses, and comfort stations, elevating the level of maintenance of park facilities, and completely revamping its programming. An innovative 1996 Neighborhoods First Project resulted in the development of recreational staffs and inspired new educational and training programs for Park District staff members. This project also helped the CPD to make its facilities and programs more responsive to the needs of local communities.

New offerings include after-school programs such as PARK Kids, which incorporates learning centers with recreational components. An array of new summer programs provide extended hours and various activities such

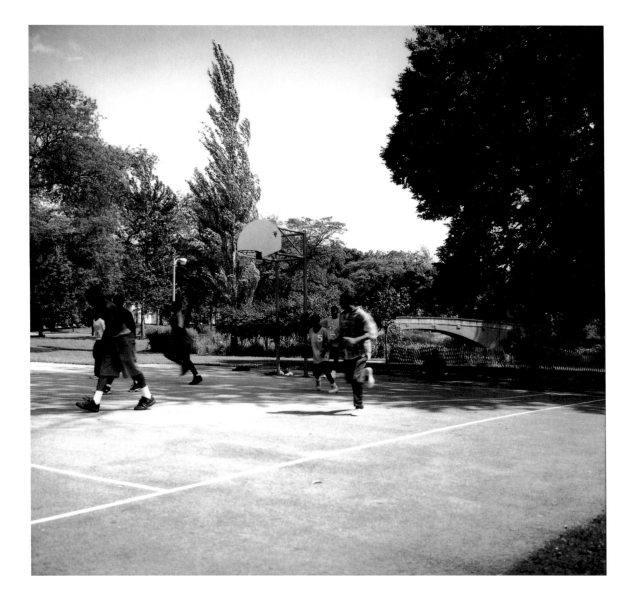

Pick-up games of basket-
ball are popular in
Sherman Park. (Summer,
2000. J.I.)

*The sweeping view of the
lakefront from Grant Park
looking northeast.
(Summer, 2000. J.B.)*

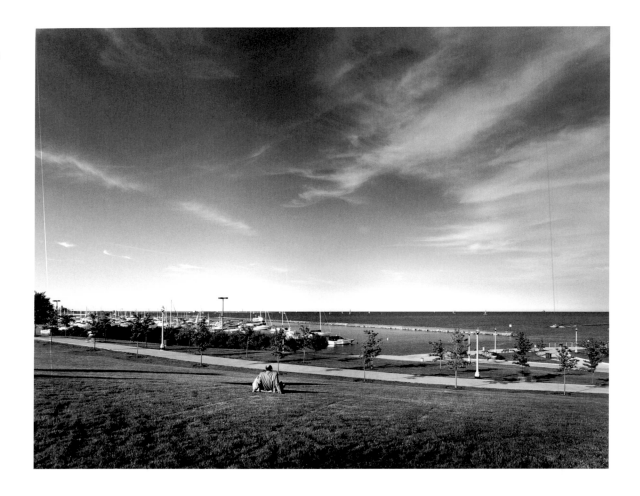

as specialty camps for sports, bicycling, golf, fishing, gardening, and Urban Campers, an outdoor education program that includes overnight camping in several parks. Throughout the year, numerous innovative programs are geared towards every age level. New therapeutic programs for people with disabilities include sled hockey for the physically challenged and beep baseball for the visually impaired. Core program areas include not only traditional ones such as physical and social activities, but also cultural enrichment, life skills, and environmental education. The CPD's programs are now nationally accredited and have received several "outstanding program awards" since 1995.

In recent years, the Park District has also benefitted from cooperative efforts with other agencies and non-profit organizations. Programming initiatives are supported by partnerships with museums, universities, professional sports teams, and federal and state agencies. During the mid-1990s, the Park District and Friends of the Parks jointly received a Lila Wallace Reader's Digest Grant to enhance community outreach and educational programs at the Garfield Park Conservatory. This led to the creation of the Garfield Park Conservatory Alliance, a non-profit organization with a full-time staff that provides programs for the conservatory. Another newly formed parks organization is the Parkways Foundation, which raises significant funding for Chicago Park District initiatives. Already, this organization has raised more than $2 million for capital projects, program scholarships, and other efforts that support the parks. A cooperative effort between the Chicago Park District and Board of Education is the Campus Park Program, in which more than 100 school lots are being replaced with green spaces. This $50 million initiative has resulted in beautiful school landscapes with gardens, playgrounds, recreational fields, and neighborhood gathering spaces throughout the city.

Another significant recent focus has been comprehensive planning efforts. A 1990 Land Policies Plan and 1998 CitySpace Plan, for example, have guided the acquisition of 200 acres of new parkland, and the promise of an additional 150 acres of open space. Long-range planning has also been undertaken in large regional parks such as Lincoln, Burnham, and Washington. Created cooperatively by the CPD, allied agencies, community groups, and park advisory councils, these plans have already helped to guide development, improve infrastructure, generate new recreational programs, and enhance operations in these large regional parks. And as a part of the Museum Campus Plan (p. 74), the city and Park District have reclaimed a 57-acre expanse of Lake Shore Drive. Constructed in 1995, the project relocated a vast stretch of roadway that had bisected parts of Burnham and Grant parks, connecting the museums and creating new plazas, gardens, and landscapes that take advantage of the site's spectacular lakefront views.

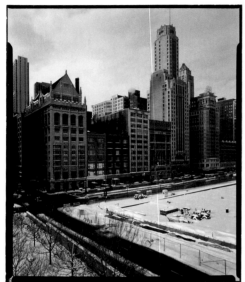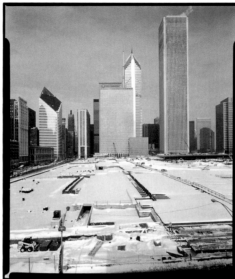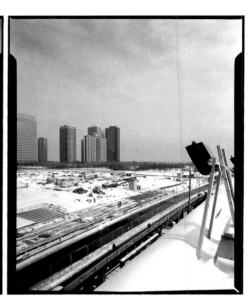

Millennium Park under construction in Grant Park, as seen from the roof of the Art Institute of Chicago. (December, 2000. J.I.)

The work to maintain and expand upon Chicago's parkland legacy is ongoing. Mayor Richard M. Daley's ambitious visions for the twenty-first century, for example, embrace the new Millennium Park. Reclaiming 16.4 acres of former railroad right-of-way that extends through Grant Park, this new development will include a 1 million square foot area of gardens, sculptures, festival sites, underground parking, indoor auditorium for music and dance performances, and outdoor music pavilion designed by world renowned architect, Frank Gehry. This tapestry of art, nature, and culture will set the standard for park design and programming well into the future, once again carrying on Chicago's tradition of "Urbs in horto—City in a garden."

1. Fort Dearborn lands dedicated as public open space in 1839 from Illinois Central vs. Illinois, 1892, reprinted in J. Theodore Fink, *Grant Park Tomorrow: Future of Chicago's Front Yard*, 1979, p. 16.

2. Reprinted in "The Public Parks of Chicago, Their Origin, Former Control and Present Government," *Chicago City Manual*, 1914, p.7.

3. Together, Olmsted and Vaux had prepared the "Greensward Plan," the winning entry in a competition to design New York City's Central Park in 1858. This plan proved to be one of the most significant works in the history of American landscape architecture. As partners, Olmsted and Vaux designed dozens of large parks in major American cities and Riverside, Illinois, the nation's first planned community. Although Olmsted went on to practice with other partners and created various kinds of landscapes, including private estates and university campuses, his parks had the greatest impact on American culture.

4. Olmsted, Vaux and Company. *Report Accompanying Plan for Laying Out the South Park*, Chicago: South Park Commission, 1871, pp 3–40.

5. West Chicago Park Commission, *Third Annual Report of the West Chicago Park Commissioners*, Chicago: 1872, p. 36.

6. Ragna Bergliot Eskil, "Natural Parks and Gardens," *The Saturday Evening Post*, v. 20, no. 36, 8 March 1930, p. 18.

7. *Ibid.*, p. 18–19.

8. Dwight Heald Perkins, *Report of the Special Park Commission to the City Council of Chicago on the Subject of a Metropolitan Park System*. Chicago: 1904, p. 39.

9. As reprinted in South Park Commission, *Report of the South Park Commissioners for a Period of Fifteen Months from December 1, 1906 to February 29, 1908, inclusive. Chicago: 1908,* p. 62.

10. Thomas McAdam, "Landscape Gardening Under Glass," *Country Life in America*, V. XXI- No. 4, 15 December 1911, p.11.

11. Jens Jensen, "Object Lesson in Placing Park Sculpture," *Park and Cemetery*, Vol. XVIII, no. 9, November 1908, p. 438.

12. West Chicago Park Commission, *Forty-seventh Annual Report of the West Chicago Park Commissioners*, Chicago: 1915, pp. 18-24.

13. Jens Jensen, "The Naturalistic Treatment," *American Landscape Architect*, January, 1930, p. 35.

14. Lincoln Park Commission, *Annual Report of the Lincoln Park Commissioners*, Chicago: 1908, p. 27.

15. Lenox R. Lohr, *Fair Management: The Story of A Century of Progress*, Chicago: Cuneo Press, 1952, p. 15.

16. George T. Donohue, "Park Consolidation in Chicago," *Parks and Recreation*, November, 1936, Vol. XX, No. 3, p.103.

17. Lois Weisberg, "Friends' Long History Remembered by Founder," *Friends of the Parks Newsletter*, Summer, 1990.

18. United States of America vs. Chicago Park District, Civil Action No. 827308, filed 30 November 1982.

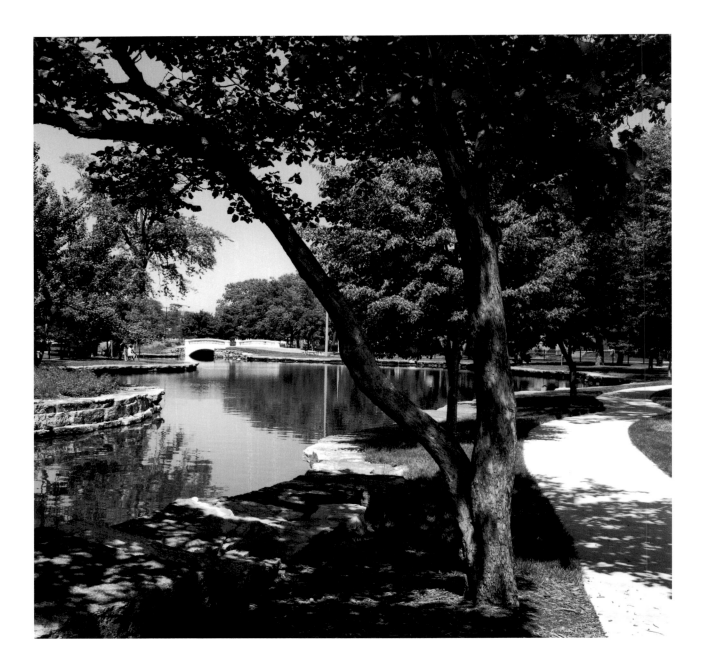

CREATED AS PART OF A SPECULATIVE REAL ESTATE DEVELOPMENT, Auburn Park lies within an area originally known as Cummorn. William B. Ogden, Chicago's first mayor, once owned much of the small village. A marshy area, the land originally drained seven miles southeastward into the Calumet River. Railroad service was established in 1852, and within the next 20 years three additional railroad lines ran through the area. Railroad workers built homes here, and in 1872 the Auburn settlement was platted. During the 1870s, real estate speculators Eggleston, Mallette, and Brownell subdivided, drained, and began developing the land. Within several years, a second group of real estate developers, Sanford McKnight, Henry Mather, and Alfred Manning, purchased the property. Sometime between the 1870s and 1890s, one of the two groups of developers created Auburn Park, an eight-acre landscape with a meandering lagoon, a remnant of the site's original wetlands. The private park helped to establish the area as an attractive and desirable community.

In 1889, the Auburn community was annexed to Chicago. The following year, the city began maintaining the privately owned park. Between 1911 and 1913, after local residents began requesting that the site become a public park, the Auburn Park Improvement Association acquired and transferred it to the city. The deed included covenants requiring that the land be forever used as a park, that the park and lagoon always be maintained, and that the name Auburn Park never be changed. The city planted trees and flowering shrubs there, and the site became known as the "beauty spot of Auburn." Between the 1930s and 1950s, Auburn Park was used for lawn tennis in the summers, and during the winters its frozen lakes were frequented by ice skaters. The Chicago Park District assumed management of Auburn Park in 1959. The Chicago Department of Transportation reconstructed the park's historic bridges during the late 1990s. The Park District followed suit by installing new walks and ornamental iron fencing, repairing the lagoon's masonry perimeter walls, and planting new trees, shrubs, perennials, and groundcovers.

BURNHAM PARK

During the mid-1890s, as the World's Columbian Exposition buildings were being demolished, the fair's Chief of Construction, Daniel H. Burnham, began making sketches of a magnificent park and boulevard that would link Jackson Park with Grant Park. Burnham's vision for a linear stretch of parkland with a series of human-made islands, Venice-like boating harbor, beaches, meadows, and playfields was presented in his 1909 *Plan of Chicago*, co-authored by architect Edward H. Bennett. Although civic groups, business associations, and the South Park Commissioners wanted to build the park, disputes with the Illinois Central Railroad over riparian rights and other legal issues delayed progress. In 1920, after property rights and government approvals were finally secured, voters approved a $20 million bond issue and landfill operations began. By the time the park was named to honor Burnham in 1927, only Northerly Island and a portion of the mainland had been filled.

A Century of Progress, Chicago's second World's Fair, took place in Burnham Park during two full seasons in 1933 and 1934. During the mid-1930s, the newly consolidated Chicago Park District used federal funds through the Works Progress Administration to complete landfill operations and improve Burnham Park. Much of the work focused on Promontory Point, a peninsula constructed of landfill between South 54th and South 56th streets.

Taking advantage of the site's breathtaking lakefront views, landscape architect Alfred Caldwell created a great meadow edged by native trees and shrubs. Caldwell suggested that he wanted Promontory Point to convey "a sense of the power of nature and power of the sea." In 1989, then in his late eighties, Caldwell consulted with the Park District on the restoration of this historic landscape. The project included re-establishing the planting palette and reconstructing the council rings in a manner sympathetic to Caldwell's original design intent.

Burnham Park is undergoing significant improvements inspired by Mayor Richard M. Daley's vision for a greener, more beautiful Chicago during the new century. At the park's northern end, 60 acres of asphalt were recently transformed into parkland as part of the Museum Campus Project. There is a new beach house, eroded shoreline is being reconstructed, and a major Soldier Field renovation project includes the replacement of parking lots with green space.

When landscape architect Alfred Caldwell helped the Chicago Park District restore Promontory Point in 1989, circular concrete benches that had not followed his specifications were replaced with the stone council rings that he had originally envisioned. (Summer, 2000. J.B.)

41

During the 1930s,
Burnham Park's landfill
operations included this
area west of Lake Shore
Drive at South 39th Street.
(November, 1938.
CPDSC.)

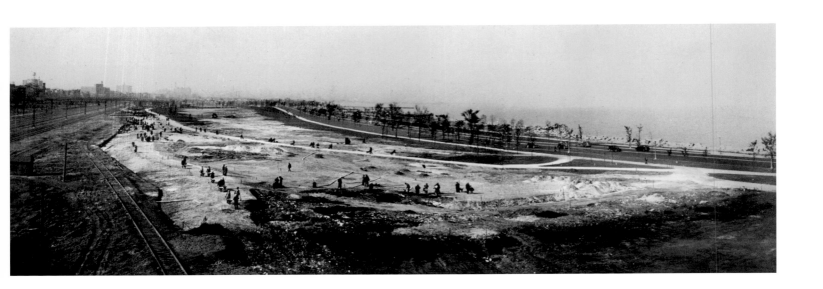

This view of Promontory Point, taken from the field house's tower, illustrates the quick pace of many of the projects that were funded by the WPA (Works Progress Administration).

By using large trees and mature shrubs, the Park District created a finished effect within a year or two of the original planting. (August, 1939. CPDSC.)

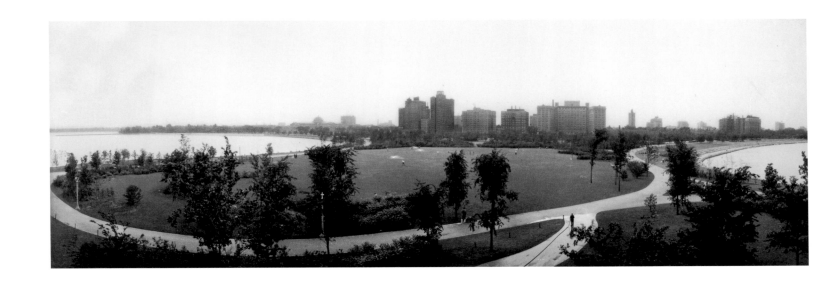

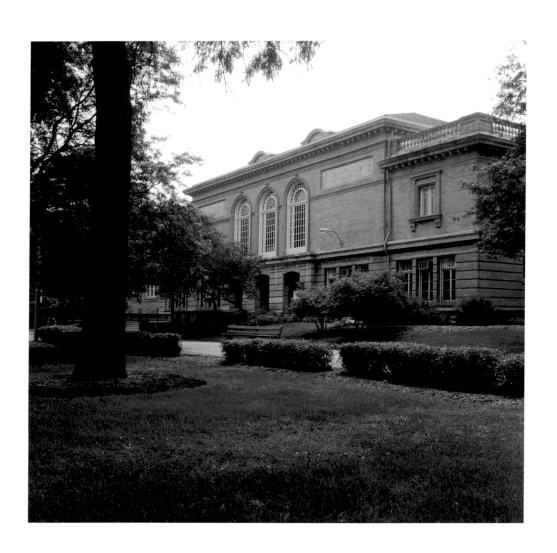

CALUMET PARK, FIRST ENVISIONED as part of the South Park Commission's revolutionary neighborhood park system in 1904, developed slowly and was not completed until the 1930s. As landscape architects, the Olmsted Brothers firm originally created plans for 14 new parks, but only 10 were initially constructed. Having purchased 40 acres for Calumet Park in 1904, the commissioners decided to delay improvements until the park could be expanded to better serve the area's growing population. At the time, the surrounding community was developing into one of the nation's great industrial areas, and vast numbers of Europeans and some of the city's earliest Mexican immigrants were rapidly settling here to work primarily in the steel mills and railyards. Recognizing this population trend as well as the site's unique frontage to Lake Michigan, the commissioners decided that Calumet Park should be much larger than originally planned.

Although the Olmsted Brothers's original plan of 1904 was never realized, the firm in 1908 designed a playground for the park. Initial, temporary improvements soon allowed people to use the beach and playfields. Meanwhile, the commissioners slowly began to enlarge the park to nearly 200 acres through the acquisition of additional property and landfill. In 1924, the South Park Commission constructed a monumental, classically inspired field house. Although the structure bears resemblance to earlier field houses designed by D. H. Burnham & Company, it was the work of South Park Commission in-house architects. After the commission's consolidation into the Chicago Park District in 1934, additional improvements were funded through the Works Progress Administration, among them completion of the park's infrastructure and landscape, upgrading of the beach, and installation of new ball fields and exterior lighting.

Today, the park remains popular, despite the neighborhood's declining steel industry. Calumet Park boasts numerous programs, including an active outdoor soccer league, a major gymnastics center, a model train club, and a collaborative effort with Chicago museums known as Park Voyagers. The park's name pays tribute to the Calumet region, which encompasses numerous South Side communities and the Calumet River basin. Early French explorers who traded with regional Indian tribes used the Norman-French word for pipe (*chamulet*) in reference to the Indians' peace pipes.

For decades Calumet Park's beach and harbor have provided relief to its surrounding working-class East Side and South Chicago neighborhoods. (ca. 1960. CPDSC.)

RIGHT PAGE
Although several nearby steel mills closed during the 1980s, the population around Calumet Park has remained stable, and the park continues to provide valuable green space and recreational facilities. (Summer, 2000. J.I.)

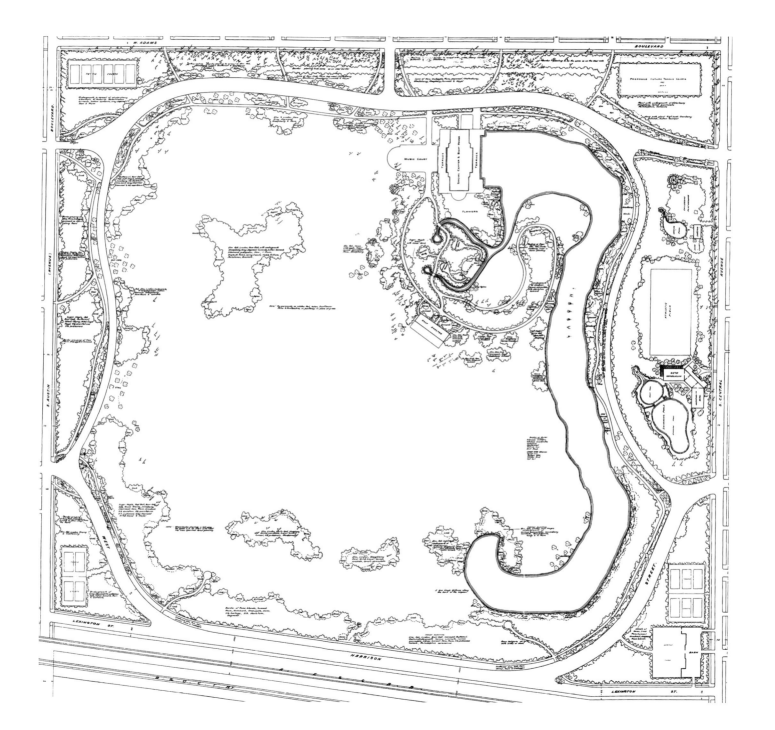

LOCATED SEVEN MILES FROM BUSTLING DOWNTOWN CHICAGO, Columbus Park is considered Jens Jensen's masterpiece: an impressive landscape of wildflowers, waterfalls, stepping stone paths, and a prairie river. Conceived between 1915 and 1920, the project represented the culmination of years of Jensen's design experimentation and conservation efforts. It was his only opportunity to create a whole new large park for Chicago on 144 acres of previous farmland at the western boundary of the city.

Jensen's vision for Columbus Park was inspired by the unimproved site's natural history and topography. Traces of a sand dune led him to believe that the site was once a beach formed by glacial action. Following that theme, he designed a series of berms, like glacial ridges, that encircled the flat interior area of the park. Along the remaining sandy sections, he created a meandering lagoon to emulate a prairie river and two waterfalls of stratified stonework to represent the river's source. Throughout the park, Jensen integrated native plants in his design.

Near the juncture of the two brooks, Jensen designed the players' green, a slightly elevated outdoor stage for theatrical performances with a lawn for the audience across the stream. The edges of the stage were thickly planted with elms, ash, maples, hawthorns, crab apples, and other types of native vegetation, leaving two "back stage" sun openings as changing areas for the performers. In the children's playground area, Jensen included his favorite feature, "the council ring," a circular stone bench for storytelling, campfires, and contemplation.

In 1953, the nine acres at the park's southern boundary were lost to the building of the Eisenhower Expressway. Despite the loss of some land and other changes made to the site at that time, Columbus Park still conveys Jensen's genius. In 1991, the Chicago Park District conducted an award-winning restoration of the waterfalls, surrounding landscape, and the Mediterranean Revival style refectory building, which is now popular for weddings and other special events. Recent efforts also include new plantings and an elevated landscape maintenance initiative.

The natural landscape surrounding Chicago inspired Jens Jensen's original plan for Columbus Park. He wrote that he hoped to "complete the country vision as far as this is possible within the city." (Report of Consulting Landscape Architect, *Annual Report of the West Chicago Park Commission, 1918.*)

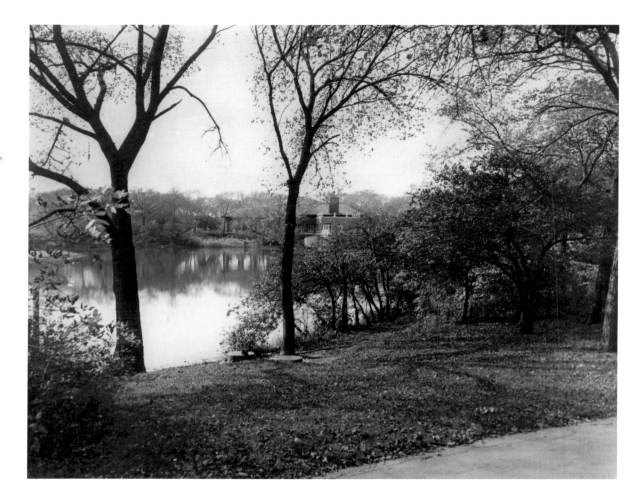

Using masses of native shrubs and trees in his design for Columbus Park's landscape, Jens Jensen carved out views across the naturalistic "prairie river." (Autumn, 1960. CPDSC.)

After Columbus Park's historic waterfalls had been dry and the surrounding landscape suffered severe deterioration for many years, the Park District conducted a thorough restoration in 1991. (Summer, 1996. J.I.)

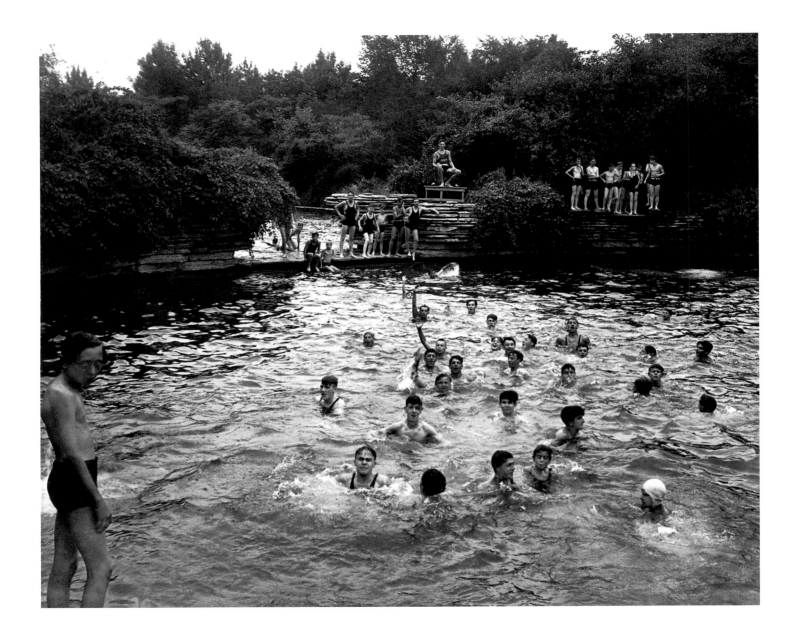

A recent performance by the Midnight Circus on Columbus Park's outdoor stage renewed Jensen's original purpose for this area. (Spring, 2000. J.I.)

LEFT PAGE
Jensen's original Columbus Park pool, meant to emulate a country swimming hole, was surrounded by walls of stratified stone and lush plantings. One of the nation's largest outdoor swimming facilities, this was replaced with a standard pool during the 1950s. (ca. 1935. CPDSC.)

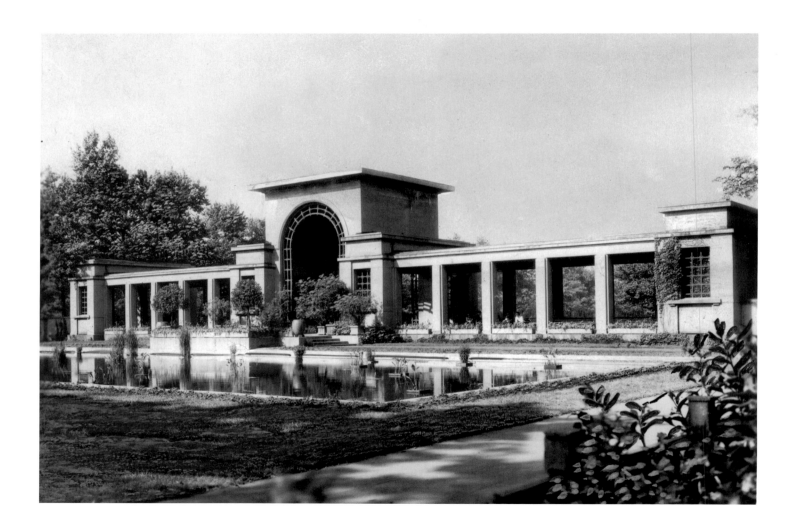

DOUGLAS PARK

SHORTLY AFTER THE ILLINOIS STATE LEGISLATURE formed the West Park System in 1869, the commissioners named the southernmost park in honor of Stephen A. Douglas (1813–1861), a United States senator remembered for his pre-Civil War presidential defeat by Abraham Lincoln, his superb oratorical skills, and for bringing the Illinois Central Railroad to Chicago. William Le Baron Jenney completed plans for the entire system of Douglas, Garfield, and Humboldt parks in 1871. He soon had tons of sand and manure hauled from Chicago's stockyards and added to Douglas Park's marshy site. Creating a small picturesque lagoon and surrounding areas of lawn and trees, Jenney completed the first small section of the park, formally opened to the public in 1879. By the late 1890s, the park also had a conservatory, gardens, and one of the city's first public bathing facilities, which included an outdoor gymnasium, swimming pool, and natatorium (no longer extant).

After being appointed as general superintendent and chief landscape architect in 1905, Jens Jensen made additional improvements to Douglas Park. Among these is a formal garden at the corner of Ogden Avenue and Sacramento Drive with an impressive shelter building known as Flower Hall.

In 1928, the West Park Commission constructed a long needed field house in the park. The structure was designed by architects Michaelsen and Rognstad, who were also responsible for other notable buildings, including the Garfield Park "Gold Dome Building" and field houses at Humboldt and LaFolette parks. In 1934, Douglas Park became part of the Chicago Park District, when the city's 22 independent park commissions merged into a single, city-wide agency. During the late 1990s, Douglas Park's field house was designated as a cultural and community center, shifting the programming focus from recreation to the arts. Today, the Park District is undertaking numerous improvements in Douglas Park, including the restoration of a historic section of the lagoon system and the creation of a new junior golf course, a facility dedicated to golf instruction for West Side residents.

Jens Jensen's formal garden in Douglas Park includes the elegant Flower Hall, a structure that he may have designed in conjunction with his friend Hugh Garden, a noted Prairie School architect. (ca. 1915. CPDSC.)

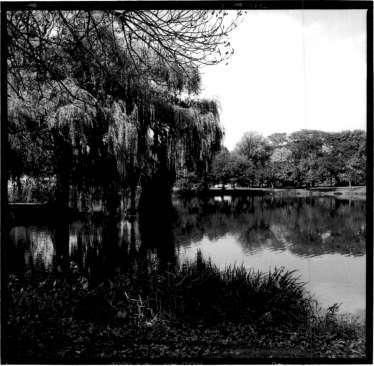

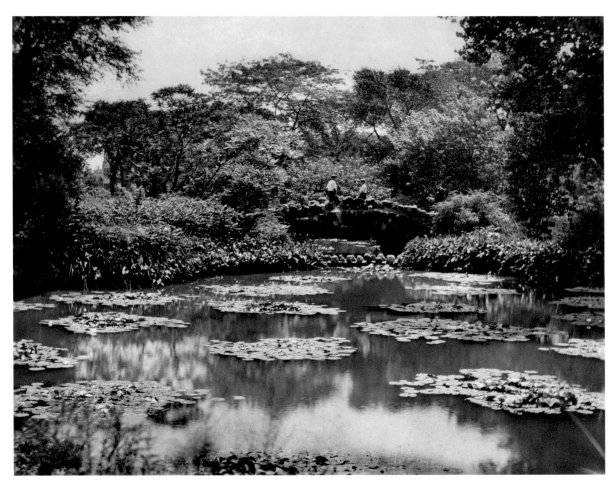

Douglas Park has several historic footbridges that were constructed during the late nineteenth century. (1922. CPDSC.)

LEFT PAGE
Douglas Park's lagoon still conveys its historic, romantic character. The lagoon has recently been restored. The field house is depicted in the left panel. (Summer, 1995. J.I.)

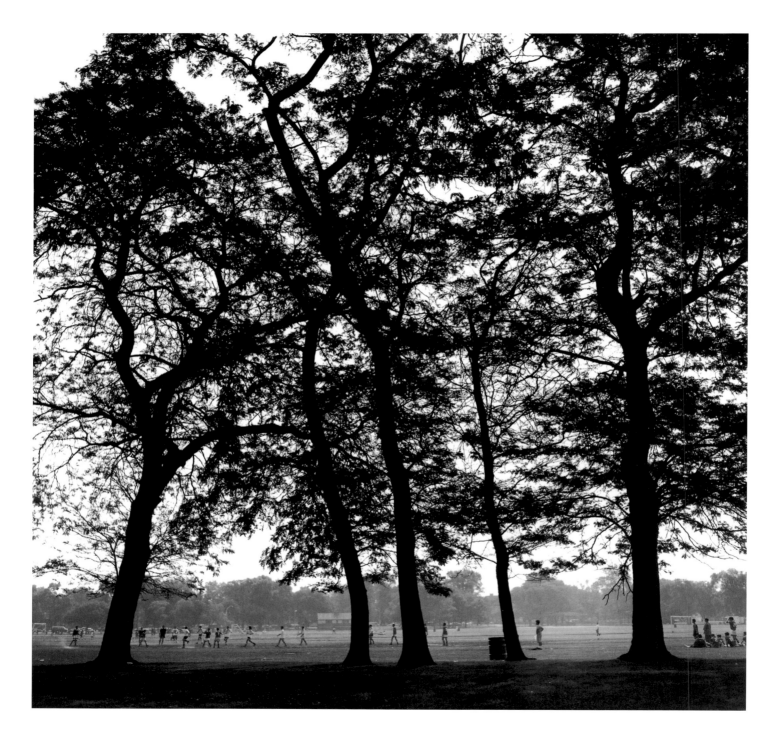

Douglas Park's great meadow is now used as soccer fields. (Spring, 1995. J.I.)

Douglas Park's southwestern edge retains a strong visual connection with the Victorian, two-story apartment buildings along bordering Marshall Boulevard. (Fall, 1995. J.I.)

FULLER PARK WAS CONCEIVED AS PART of the South Park Commission's seminal neighborhood park system in 1904. Although the first 10 South Side parks opened to the public in 1905, Fuller Park's development was delayed due to community protests about its proposed location. A nearby alternative was soon agreed upon, the commissioners acquired the 10.5-acre site between 1905 and 1908, and the park opened in 1911.

The new site had some difficult conditions, but, as landscape architects, the Olmsted Brothers were able to turn these problems into assets. For instance, by placing the men's running track below a railroad embankment, they created an attractive ornamental concrete grandstand that buffered the unsightly raised train tracks.

The delay in implementing the Fuller Park plan provided architect Edward H. Bennett of D.H. Burnham & Company an opportunity to refine architectural design concepts. Relying on a familiar vocabulary of classical forms and ornamentation, Bennett used exposed aggregate concrete, the same building material used to construct the initial 10 field houses. Fuller Park's architecture, however, was more monumental than the earlier buildings. To make the best use of the site's relatively small size, the field house was conceived as a symmetrical complex of buildings flanking a central, outdoor children's courtyard.

South Park Commissioner Judge John Barton Payne donated funds for murals in the field house's assembly hall. Renowned muralist John Warner Norton painted the artwork, which feature scenes of Spanish and French explorers, thereby providing a lesson in American frontier history to the park's immigrant patrons.

Over the years, Fuller Park's landscape and architecture have retained their strong historic integrity. The Chicago Park District has undertaken a number of restoration and improvement efforts that address the bath house and swimming complex, the playground, and the field house's murals. The park honors Melville W. Fuller (1833–1910), chief justice of the Illinois Supreme Court from 1888 to 1910 and a South Park commissioner from 1882 to 1887. As a leader of the Chicago Bar, Fuller served as counsel for the city in riparian rights disputes related to the development of parkland on the lakefront.

Despite Fuller Park's small size, over the years it has continued to meet community needs while retaining its historic features. (Summer, 2000. J.I.)

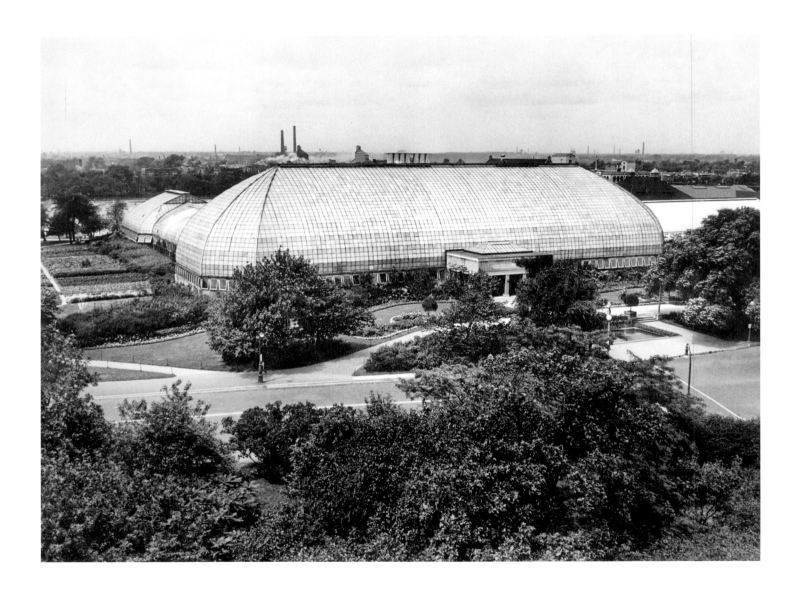

ORIGINALLY KNOWN AS CENTRAL PARK, Garfield Park was conceived in 1869 as the centerpiece of the West Park System and renamed in 1881 after the assassination of President James A. Garfield (1831–1881). William Le Baron Jenney, best known today for creating the nation's earliest skyscrapers, had completed plans for the entire ensemble of Humboldt, Garfield and Douglas parks 10 years earlier. As the ambitious plans could not all be realized at once, Garfield Park developed in stages, beginning with the east lagoon. By the late 1890s, the park also had a small conservatory and gardens, an exotic Victorian bandstand, a horse racing track, small shelters, and rustic site furnishings.

In 1906, Jens Jensen began improving and repairing the three west parks. This included replacing three small Victorian conservatories with the much larger Garfield Park Conservatory, designed by Jensen in conjunction with a New York City engineering firm, Hitchings and Company. Jensen did not want the new conservatory to look like a palace, château, or villa, as he believed many others did at the time. Rather, he designed the exterior of the structure to emulate the simple form of a great Midwestern haystack. Inside, he created landscape compositions that looked as though they were magically enclosed in a glass structure. Jensen also removed the park's race track, installing the first public golf course on Chicago's West Side. Nearby, he created an elegant formal garden with rectangular water courts and floral beds. In 1909, this was the site of an outdoor sculpture exhibit co-sponsored by the Municipal Art League.

In 1928, the West Park Commission constructed the "Gold Dome Building" in Garfield Park to provide a new administrative headquarters for the West Park Commission. When the commission became part of the Chicago Park District in 1934, the "Gold Dome" building became Garfield Park's field house, which is actively used today. Several years ago, the structure underwent a thorough restoration project that included completely reconstructing and reguilding the dome. The Garfield Park Conservatory has also benefited from recent improvements. The building's 1950s entryway was replaced with a new addition that has a front desk, bathrooms, and community and classroom spaces. Several other conservatory houses have been restored and re-designed, including a new Elizabeth Morse Genius Children's Garden, made possible by the Parkways Foundation.

Designed to emulate a great Midwestern haystack, the Garfield Park Conservatory's exterior design had clean lines and little ornamentation. It stood in stark contrast to other conservatories of the period. (ca. 1930. CPDSC.)

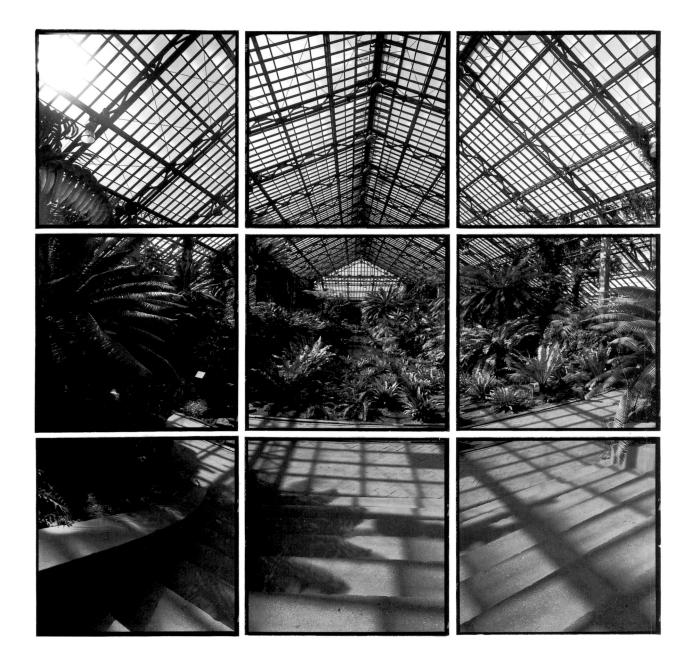

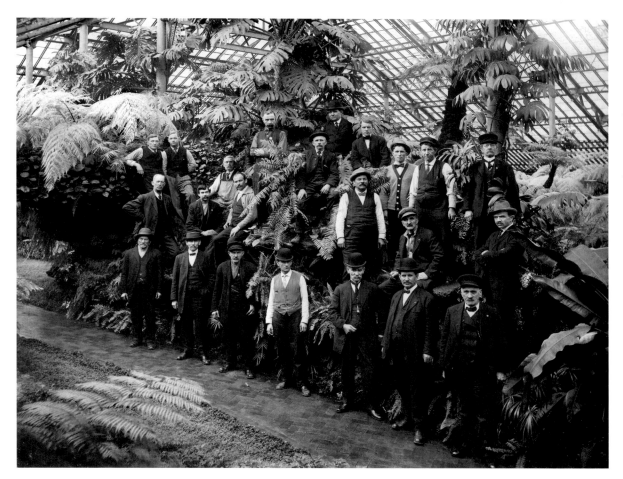

During the early twentieth century, Garfield Park Conservatory's gardeners were responsible for managing the facility's seven rooms. At that time, a gardener's salary was $780 per year; in 2001, a floraculturist earns $35,000 per year plus benefits. (1913. CPDSC.)

When it opened to the public in 1908, Jensen's Garfield Park Conservatory was referred to as "landscape art under glass." The premier space, the Fern Room, was inspired by the prehistoric landscape of Illinois, featuring a wonderful composition of water, rock, and plants. (Spring, 2000. J.I.)

The eastern portion of Garfield Park's lagoon was the earliest section of completed landscape. This part of the landscape, including the reconstructed suspension bridge, reflects the work of the park's original designer, William Le Baron Jenney. (Summer, 2000. J.I.)

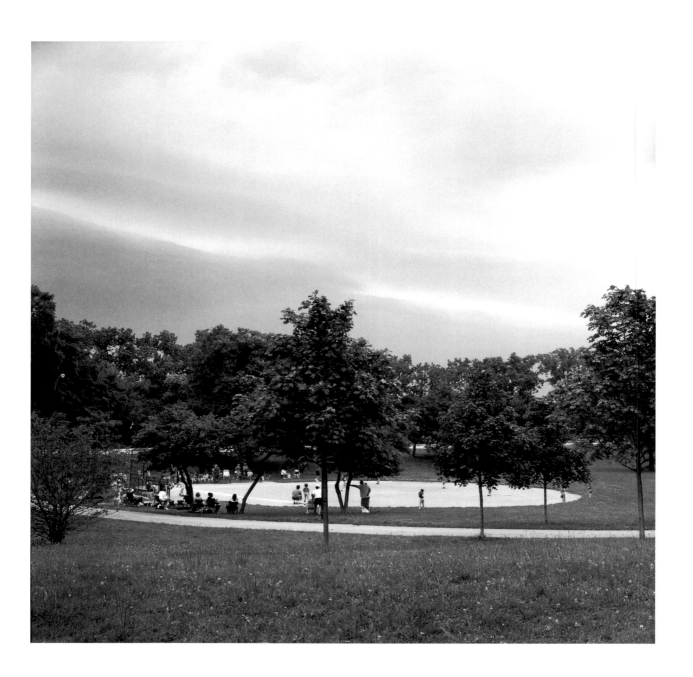

THE ALBANY PARK DISTRICT, one of 22 independent park districts, began creating Gompers Park during the mid-1920s. In 1917, local residents had formed the district to provide modern park facilities and to improve the banks of the Chicago River's North Branch throughout their rapidly developing Northwest Side neighborhood. After identifying nearly 40 acres of wooded farmland along North Branch, the district hired landscape architect Henry J. Stockman to transform the property into parkland. Improvements began almost as soon as initial land purchases were completed in 1927. In addition to wooded areas and a natural stream dammed to create lagoons, by the early 1930s the property had basketball courts, archery ranges, football fields, and playgrounds. Clarence Hatzfeld, a Chicago architect and member of the Albany Park board, designed the park's Tudor Revival style field house, which was constructed in 1932.

Early on, Gompers Park was known as Matson Park, in honor of Samuel Matson, the Albany Park District's superintendent. Henry A. Schwartz, an official of the shoemakers union who served as the Albany Park District's president, convinced the park board that it was inappropriate to name the park for a living person. In response, the park was renamed in tribute to Samuel Gompers in 1929. Gompers (1850–1924) was elected as president of the local cigar makers' union in 1875, and he became the American Federation of Labor's first president in 1886.

In 1934, financial pressures brought on by the Great Depression prompted the consolidation of the city's 22 independent park districts into the Chicago Park District (CPD). Using federal funding through the Works Progress Administration, the CPD soon began to rehabilitate the southern portion of Gompers Park, constructing tennis courts, a footbridge over the river, and a dam and spillway for the lower lagoon. After adding a wading pool in 1946, the CPD built a full-sized swimming pool 30 years later. During the mid-1990s, with tremendous community support, the CPD undertook a project to restore the wetlands along the southern bank of the river, following plans prepared by the U.S. Department of Agriculture.

Recreational facilities such as junior ball fields, basketball and tennis courts, and a swimming pool are woven into Gompers Park's beautiful, undulating landscape. (Summer, 2000. J.I.)

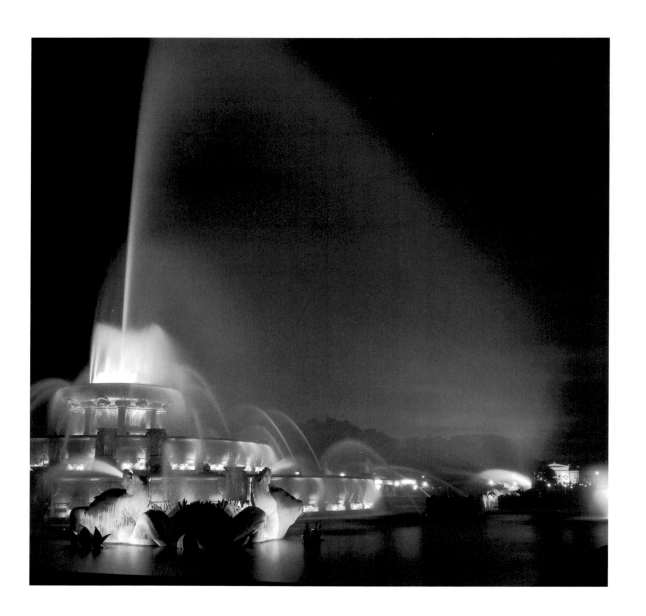

Proudly referred to as Chicago's "front yard," Grant Park is the site of many festivals and three world-class museums: the Art Institute of Chicago, the Field Museum of Natural History, and the Shedd Aquarium. (The Adler Planetarium is also nearby.) Grant Park's centerpiece is the Clarence Buckingham Memorial Fountain, built in 1927 to provide a monumental focal point while protecting breathtaking lakefront views.

During the 1830s foresighted citizens, fearing commercial development along the lakefront, lobbied to save this site as open space. Officially named Lake Park in 1847, lakeshore erosion soon posed a major threat. The Illinois Central Railroad agreed to build a breakwater in exchange for permission to construct an offshore train trestle. After the Great Fire of 1871, the area between the shore and trestle became a dump site for charred rubble, representing the first of many subsequent landfill additions.

Assuming control in 1901, the South Park Commission renamed the park to honor Ulysses S. Grant (1822–1885), 18th president of the United States. Daniel H. Burnham, in his famous 1909 *Plan of Chicago*, envisioned Grant Park as a landscape designed in the French Renaissance style complete with museums and civic buildings. Construction, however, was stalled by lawsuits launched by businessman Aaron Montgomery Ward, who sought to preserve the park's open character. Finally, in 1911, the Illinois Supreme Court ruled in Ward's favor.

Landfill at the park's southern border allowed construction of the Field Museum. The park continued to evolve slowly, following plans by Edward H. Bennett, co-author of the *1909 Plan of Chicago*. In 1934, Grant Park became part of the newly consolidated Chicago Park District, which completed improvements using federal relief funds.

Recent improvements to Grant Park include the planting of hybrid elms, restoring and re-lighting the Clarence Buckingham Memorial Fountain, adding new Parisian style comfort stations and concession buildings, and the restoration of several classically designed bridges and Congress Plaza. The northern end of Grant Park is also the site of a major face-lift with the construction of the multi-million dollar Millennium Park, through which old railbeds are being transformed into gardens, festival sites, and performance spaces.

The gift of Kate Buckingham in honor of her brother Clarence, the Buckingham Memorial Fountain was the world's largest decorative fountain when it was dedicated in 1927. The Art Institute of Chicago continues to administer the Buckingham Fund, an endowment that supports the fountain's maintenance and conservation. (Summer, 2000. J.I.)

Modeled after California's Hollywood Bowl, Grant Park's original band shell was constructed at the south end of Hutchinson Field in 1933. Concerts were held there until 1976, when the Park District built a new band shell in Butler Field. (1938. CPDSC.)

RIGHT PAGE

Between 1915 and the late 1920s, rostral columns, balustrades, and other ornamental concrete elements were constructed in Grant Park. These elements, designed by Edward H. Bennett, were complemented by formal rows of crabapple trees planted by the Park District during the late 1930s. (Spring, 2000. J.I.)

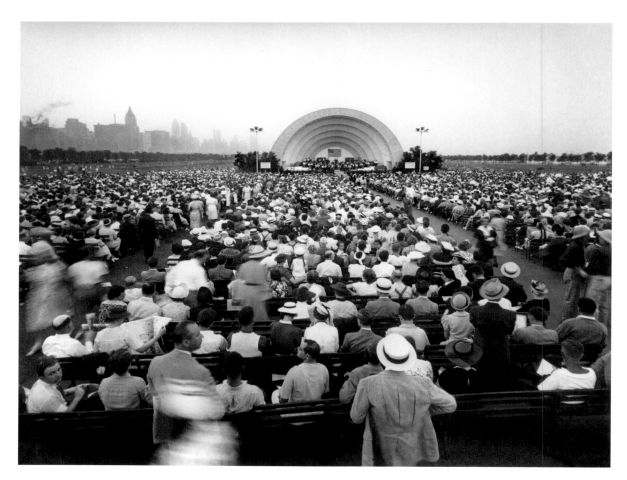

During the late 1990s, the Museum Campus Project resulted in major improvements to both Grant and Burnham parks. This area, once a vast surface parking lot just north of the Field Museum of Natural History, now offers beautiful terraced gardens and dramatic views of Lake Michigan and the Chicago skyline. (Summer, 2000. J.B.)

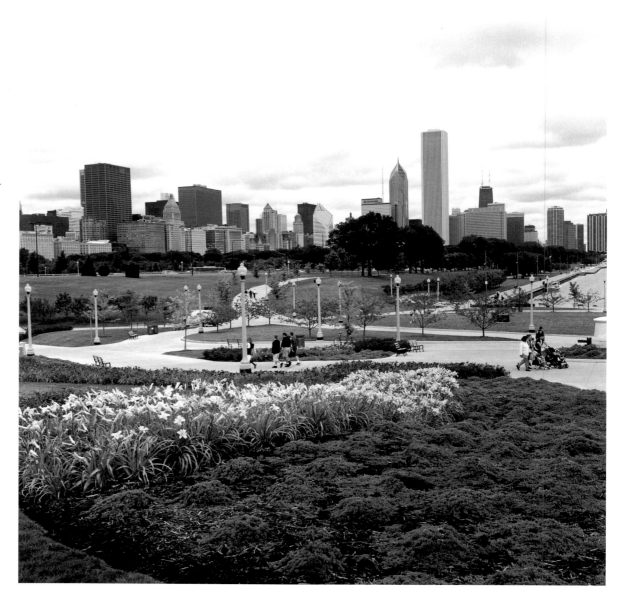

Grant Park is a tapestry of impressive elm trees, formal walkways, neo-classical architecture, and beautiful gardens and sculptures. (Summer, 2000. J.B.)

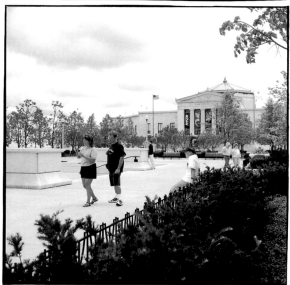

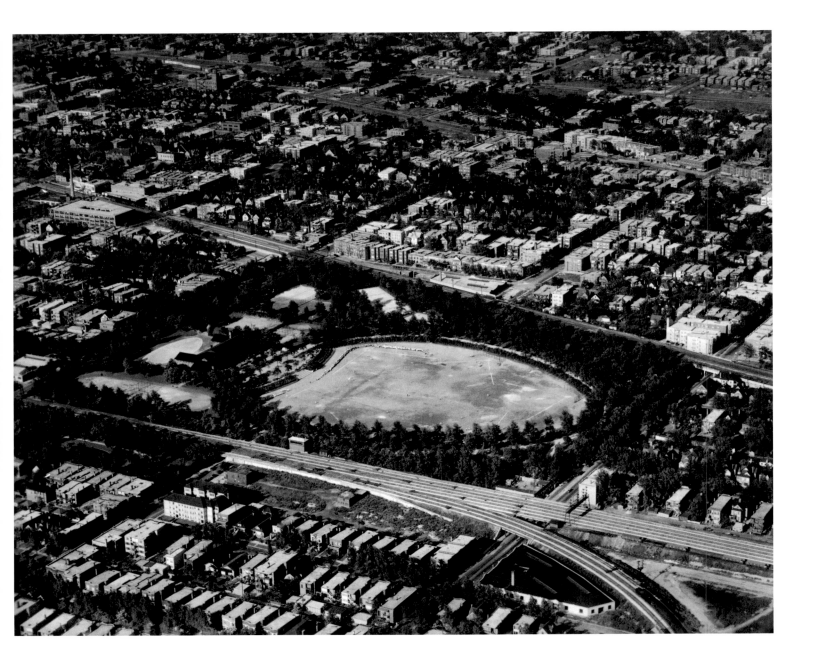

CONSTRUCTED IN 1904, Hamilton Park honors Alexander Hamilton (ca. 1755–1804), advisor to George Washington and first secretary of the U.S. Treasury who was killed in a duel with Aaron Burr. Significantly, it was among the South Park Commission's first 10 neighborhood parks, providing relief to Chicago's congested tenement districts and establishing a new national standard for park design and programming. As part of this initiative, the architectural firm, D.H. Burnham & Company, developed an entirely new building type, the field house. Inspired by Chicago's renowned settlement houses, these innovative park structures included assembly halls, classrooms, clubrooms, cafeterias, the earliest local branch libraries, indoor gymnasiums, locker rooms, and public bathing facilities. Burnham's field houses soon influenced the construction of similar buildings in parks throughout the nation and abroad.

While the other nine parks that opened in 1905 had outdoor gymnasiums, swimming pools, running tracks, and children's playgrounds, these features were originally omitted from Hamilton Park's plan because neighborhood residents felt uncertain about some of these newer program elements, asserting that they wanted a "choice ornamental park." The Olmsted Brothers, as landscape architects for the park, therefore created a large, oval sunken field as the centerpiece of their brilliant plan. In addition to providing magnificent views, this field was used for ball games during summer and, when flooded, for ice skating in winter. Soon after Hamilton Park opened to the public in 1905, community members noted the success of the other neighborhood parks and petitioned for the omitted features. Within the next several years, outdoor gymnasiums, a playground, and tennis courts were installed.

Over the years, Hamilton Park underwent several significant changes. In 1916, noted Chicago artist, John Warner Norton, painted a series of murals in the field house lobby relating to America's political history. To accommodate increasing demands for indoor space, the South Park Commission's architects created a major building addition during the early 1930s, including an expanded branch library and a large new Art Deco style auditorium. During the 1970s, the Chicago Park District constructed an outdoor swimming pool, as had been requested for many years.

The sunken oval field remains the dominant feature of the Olmsted Brothers's plan for 30-acre Hamilton Park. (ca. 1930. CPDSC.)

Among the nation's earliest field houses, the one at Hamilton Park includes beautiful interior details such as paired Ionic columns and a monumental sense of architectural space. (Summer, 2000. J.B.)

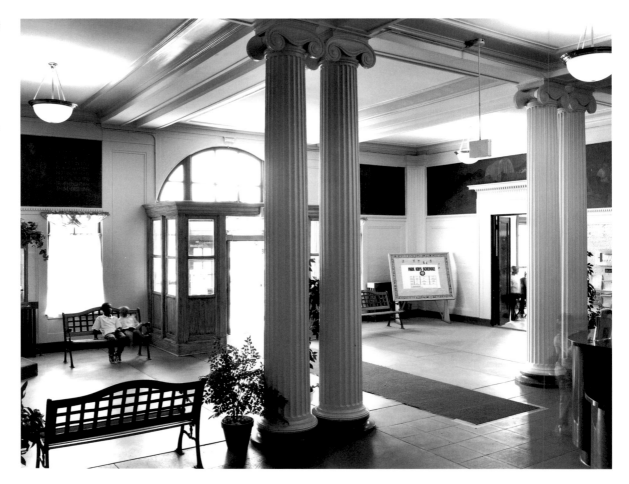

Today, Hamilton Park's sunken oval field is used for baseball, softball, soccer, and football. (Summer, 2000. J.B.)

*Meant to emulate a natu-
ral "prairie river," Jensen
edged his meandering
Humboldt Park waterway
with aquatic plants such as
arrow root, cattails, pick-
erelweed, and water lilies.
(1941. CPDSC.)*

IN 1869, SHORTLY AFTER THE CREATION OF THE WEST PARK SYSTEM, neighborhood residents requested that the north-ernmost park be named in honor of Baron Freidrich Heinrich Alexander Von Humboldt (1769–1859), the famous German scientist, naturalist, and explorer. Two years later, William Le Baron Jenney completed plans for the entire ensemble of Humboldt, Garfield, and Douglas parks and connecting boulevards. Construction of Humboldt Park was slow, however, and the original plan only guided the construction of the northeastern section of the landscape.

Jens Jensen, who had begun as a West Park Commission laborer, worked his way up to superintendent of Humboldt Park during the mid-1890s. In response to Jensen's efforts to fight the politically entrenched system, the commissioners fired him in 1900. Five years later, during major political reforms, a new park board appointed Jensen as general superintendent and chief landscape architect for the entire system. Deteriorating and unfinished areas of Humboldt Park allowed Jensen to experiment with his evolving Prairie style. For instance, Jensen extended the park's existing lagoon into a long, meandering "prairie river." Inspired by the natural rivers he saw on trips to the countryside, Jensen designed hidden water sources that supplied two rocky brooks that fed the waterway. Nearby he created a circular rose garden and an adjacent naturalistic perennial garden. Jensen designated an area diagonally across from the rose garden as a music court for concerts, dances, and other special events. He com-missioned Prairie School architects Schmidt, Garden, and Martin to design an impressive boat house and refec-tory building at one end of the historic music court.

Today, numerous improvements in Humboldt Park include the conservation of Edward Kemeys's bronze bison sculptures, restoration of the lagoon and site features such as Prairie style lanterns and urns, and rehabili-tation of the historic Stables and Receptory Building as a cultural center. A soon-to-be restored boat house, a des-ignated Chicago Landmark, will serve as a fully accessible facility offering paddle boat service, bathrooms, a concession, and a nature center.

In recent years, Jensen's circular rose garden has undergone some improvements, but it no longer includes roses. (Summer, 2000. J.I.)

In 1908, Humboldt Park hosted an outdoor art exhibition that was co-sponsored by Chicago's Municipal Art League. Small plaster versions of sculptures by notable artists, including Lorado Taft, were displayed in the rose garden and water court as part of this exhibit. (1908. CPDSC.)

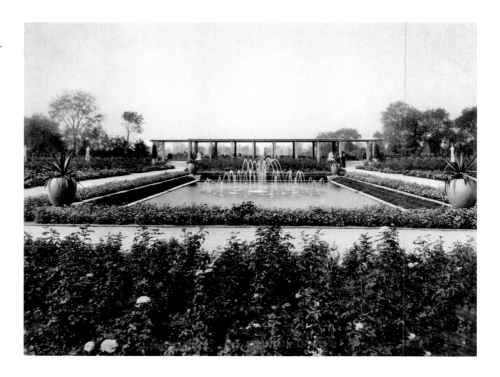

Just west of the rose garden, at the fork of the "prairie river," Jensen included lush perennial plantings, a walking path, and sitting areas. (July, 1918. CPDSC.)

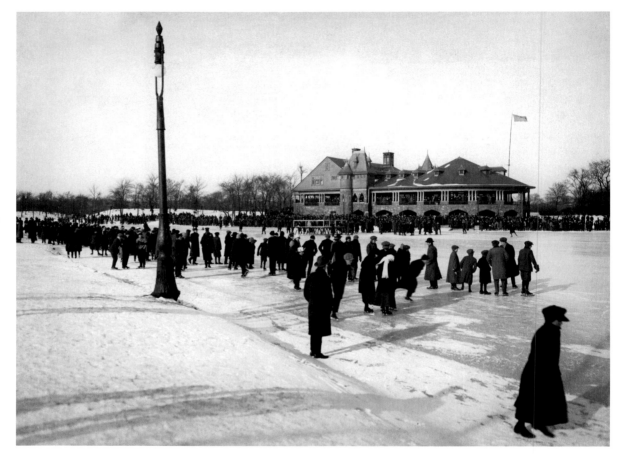

Humboldt Park's Victorian refectory building was generally used for summer parties and special events. In 1916, when the first Silver Skates event took place on the park's frozen lagoon, hundreds of spectators lined up along the edges and on the refectory's verandah to watch the speed skating competition. The building was torn down in 1927 to make way for a large field house. (1916. CPDSC.)

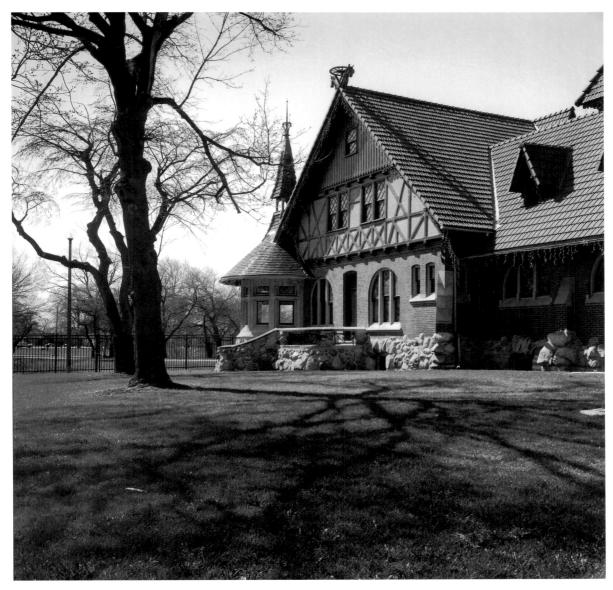

The Stables and Receptory Building, designed by architects Frommann and Jebsen, was completed in 1896. It provided Humboldt Park with stables, storage facilities, and offices, including Jens Jensen's office in the corner turret. After a fire destroyed a significant portion of the structure in 1992, the Park District reconstructed the building and converted it into a cultural center. (Spring, 2000. J.I.)

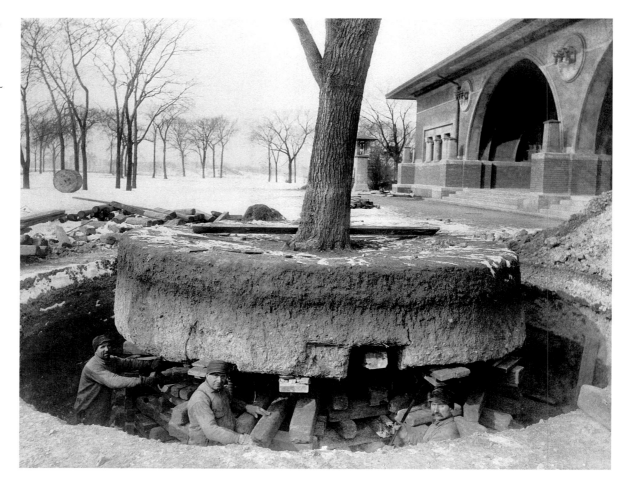

During the early twentieth century, the West Park Commission managed its landscapes with great sensitivity to nature. Laborers spent several winter days digging and transplanting this mature tree to its new site near the boat house. (Winter, 1907. CPDSC.)

Originally displayed in plaster in a Garfield Park garden in 1909, sculptor Edward Kemeys's pair of bison was recast in bronze and installed in Humboldt Park's rose garden two years later. Kemeys, who specialized in sculptures of animals, was also responsible for the famous pair of lions that flank the Art Institute of Chicago. (Winter, 2000. J.I.)

THE TREATY OF 1816 created a territorial boundary between the Pottawattomie Indians and the United States government. Extending through what is now considered Chicago's West Rogers Park community, this boundary line remained in effect only through 1833, when the Pottawattomies were forced entirely from the area by white settlers.

Indian Boundary Park was the second and largest of the four parks created by the Ridge Avenue Park District, the first of 19 independent park commissions established after 1896 to serve areas annexed to the city. The Ridge Avenue Park District began to acquire land for the recreational facility in 1915. Richard F. Gloede, a designer of estate landscapes along the North Shore, developed an early plan for the park. During the mid-1920s, the Ridge Avenue Park District opened a small zoo, one of only two existng zoos in Chicago and initially housing only a lone black bear. The 1929 Tudor Revival field house, designed by architect Clarence Hatzfeld, features ornamentation inspired by the park's name.

In 1934, the Ridge Avenue Park District was consolidated into the Chicago Park District. Over the years, several attempts were made to do away with the park's small zoo. The well-organized community, however, has always been committed to saving it.

Indian Boundary Park is unusual in that its eastern lawn flows seamlessly into the front yards of neighboring apartment buildings. This feature was so well received that the Chicago Park District closed off part of adjacent Estes Avenue during the 1960s, which transformed the roadway into green space along the park's northern edge. During the 1980s, the Park District worked with the community to build an extensive soft surface playground with a design inspired by the park's name, and other recent improvements include the restoration of the lagoon and a small area of prairie plantings. Indian Boundary Park hosts summer concerts in collaboration with the Chicago Symphony Orchestra as well as Jazz Café Evenings that provide an open microphone format for local talent.

Indian Boundary Park's recent lagoon restoration project included the rescue of turtles discovered during the dredging process. Today, the Park District is working to control the large population of resident waterfowl. (Summer, 2000. J.B.)

Although Indian Boundary Park lacks many of the active features of other parks such as ball fields and basketball courts, its zoo, playground, and beautiful grounds have always attracted a large and diverse community. (Summer, 2000. J.B.)

JACKSON PARK WAS DESIGNED BY FREDERICK LAW OLMSTED on three different occasions. In the park's original plan of 1871, Olmsted and his partner, Calvert Vaux, conceived of this as the eastern division of a grand 1,055-acre landscape known as South Park. Although the plan included an intricate lagoon system linked to Lake Michigan, implementation was delayed by land acquisition problems and the loss of legal documents in the Great Fire of 1871.

Officially named Jackson Park in 1880 in honor of Andrew Jackson (1767–1845), seventh president of the United States, the site was selected for the World's Columbian Exposition a decade later. Olmsted helped to transform the unimproved site into the monumental "White City," which opened in 1893. To provide refuge from the bustling fair, Olmsted re-shaped a sandy peninsula with tremendous native oak trees into Wooded Island, allowing only one structure, Ho-o-den, Japan's pavilion.

In 1895, Olmsted's firm, then Olmsted, Olmsted and Eliot, began returning the site into parkland. Remaining true to the original plan, this scheme included a vast interconnected lagoon system. It also temporarily retained the fair's Fine Arts Building as the Field Museum of Natural History.

In 1899, the commissioners decided to install in Jackson Park the first public golf course west of the Allegheny Mountains. Within the following decade, the Olmsted Brothers consulted on the expansion of Jackson Park's beach at 63rd Street. This resulted in 10 acres of landfill and an impressive classical bathing pavilion built between 1916 and 1919.

During the early 1930s, the Fine Arts Palace from the 1893 fair was rehabilitated and converted into the Museum of Science and Industry. Its opening in 1933 coincided with Chicago's second world's fair, *A Century of Progress,* in nearby Burnham Park. After that fair, the Chicago Park District moved some of its elements to create a Japanese garden on Jackson Park's Wooded Island. Improved several times over the years, this was renamed the Osaka Garden in 1992 to commemorate the 20th anniversary of Chicago's partnership with Osaka as a sister city. A second Jackson Park garden dating to the 1930s, the circular perennial garden, was also recently restored.

Designed by Chicago Park District landscape architect May E. McAdam during the late 1930s, the Jackson Park Perennial Garden follows the circular form of an earlier, sunken lawn panel. The Park District's recent restoration of the garden benefitted greatly from the assistance of volunteers. (Summer, 2000. J.B.)

Jackson Park's beaches became racially integrated as an influx of African-Americans settled in nearby Hyde Park and Woodlawn neighborhoods during the 1950s and 1960s. The beaches were especially popular in those days before air conditioning became ubiquitous. (Summer, 1964. CPDSC.)

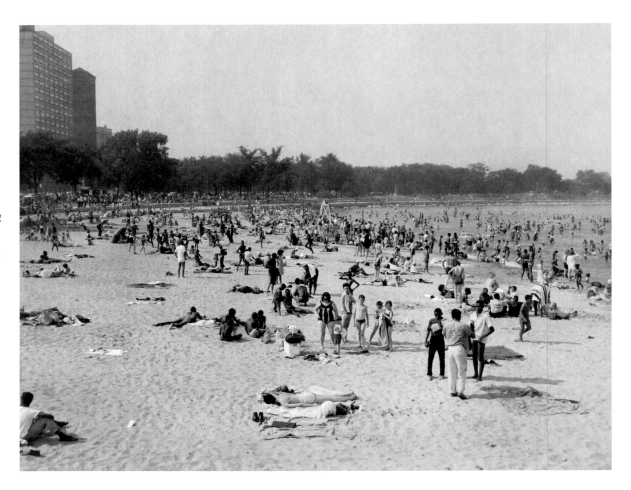

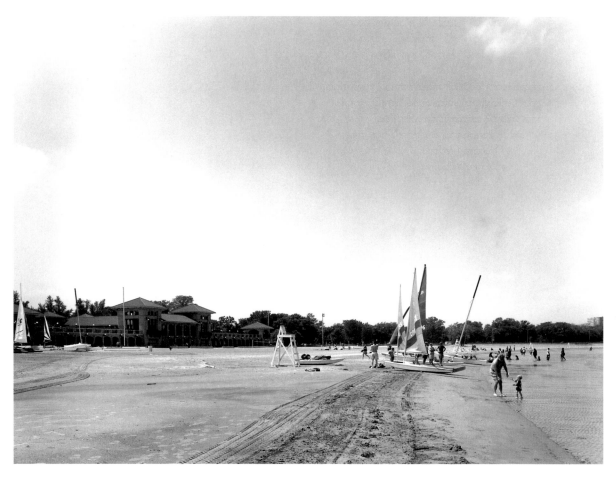

Created during World War I, the 63rd Street Beach is the largest area of Jackson Park made from landfill. The Park District has developed this beach and adjacent harbor into a major water recreation center offering parasailing, kayaking, pedal boating, and sailing. (Summer, 2000. J.B.)

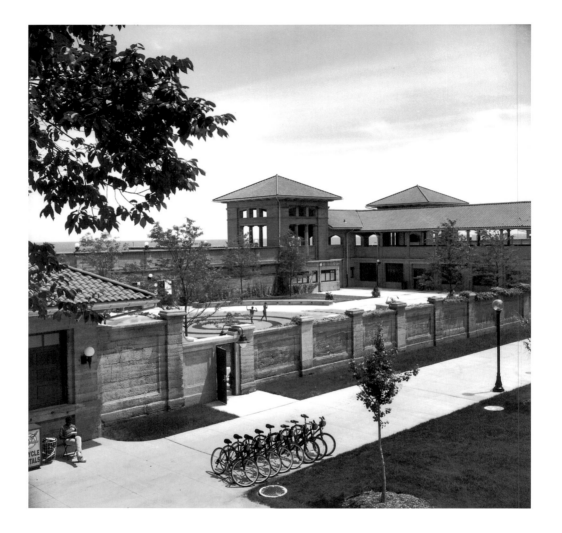

Completed in 1919, the Jackson Park bathing pavilion was designed by the South Park Commission's in-house architects. The large courtyards, once the location of hundreds of changing booths, now offer open plazas and an interactive water fountain donated by the Max Schiff Foundation. (Summer, 2000. J.I.)

After the Jackson Park bathing pavilion suffered severe deterioration over a number of years, the Park District conducted a thorough $8 million restoration project during the late 1990s. Used by beach patrons, boaters, and day campers, today the facility is also available for rental for parties, weddings, and other special events. (Summer, 2000. J.I.)

The Osaka Garden has been improved and restored many times, often relying on expertise from Japanese landscape designers. In 1992, the garden was named in honor of one of Chicago's sister cities, Osaka, Japan. (Summer, 2000. J.B.)

LEFT PAGE
Located on Jackson Park's historic Wooded Island, the Osaka Garden was created in 1935. At that time, the garden was adjacent to the historic "Ho-o-den" Japanese pavilion. Originally installed for the 1893 World's Columbian Exposition, the pavilion was destroyed by fire in 1946. (Summer, 2000. J.B.)

Jackson Park's lawn bowling green and club house have been used continuously since their creation in 1927. Today, the Lakeside Lawn Bowlers make full use of the facility. (Summer, 2000. J.I.)

BELOW RIGHT

A beautiful landscape edged by large groupings of mature trees, the Jackson Park Golf Course dates to 1899. It is the oldest public course west of the Allegheny Mountains. (Summer, 2000. J.I.)

The Museum of Science and Industry was constructed as the Palace of Fine Arts for the World's Columbian Exposition of 1893. For years, the oak grove dotting the banks of the adjacent Columbian Basin has attracted picnickers. (Summer, 2000. J.I.)

BELOW RIGHT

After the Columbian Exposition, several classically designed structures were built in Jackson Park. This golf shelter at the 9^{th} hole dates to 1912. (Summer, 2000. J.I.)

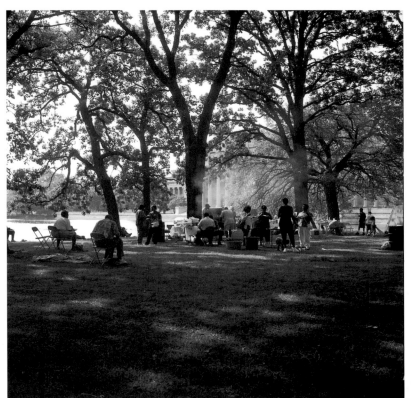

In 1918, Jens Jensen envisioned a new type of neighborhood center for Chicago's West Side whereby a public school in a beautifully designed, naturalistic landscape would provide recreational and cultural amenities to the entire community. Jensen created a plan to integrate new parkland with the Lloyd School in the Austin neighborhood. Recommending the demolition of the existing school and acquisition of adjacent land, Jensen conceived of new adjoining school and gymnasium buildings in a lushly planted setting with children's gardens, bird garden, swimming lagoon, prairie-like playfields, and outdoor theater. The West Park Commission acquired the proposed site and began negotiating with the Board of Education. Shifting political tides, however, led to Jensen's dismissal from the West Park Commission in 1920, and the innovative School Park plan was never realized.

In 1925, after the site sat unimproved for several years, the West Town Chamber of Commerce sent a letter to the commissioners complaining about the park's unfinished state. The following year, a delegation submitted petitions signed by 100,000 citizens requesting that the park be named in honor of the Progressive politician, Robert M. La Follette (1855–1925), a U.S. congressman, senator, and three-term governor of Wisconsin who was nationally known for fighting corruption and bettering the lives of children, women, farmers, and workers.

In 1927, voters approved a $10 million bond issue allowing the West Park Commission to construct a number of new park buildings and landscape improvements. The initiative included $600,000 for a field house in La Follette Park. Designed by architects Michaelsen and Rognstad, the impressive Italian Renaissance Revival style building, with its large auditorium, two gymnasiums, indoor swimming pool, lobbies, promenade, and gallery, was considered a fitting memorial to the revered La Follette.

La Follette Park became part of the newly consolidated Chicago Park District in 1934. In recent years, the park has received numerous improvements, including a new in-line skating rink and a major renovation to the field house. The Park District also recently undertook a community process through which neighborhood residents helped plan future improvements for La Follette Park.

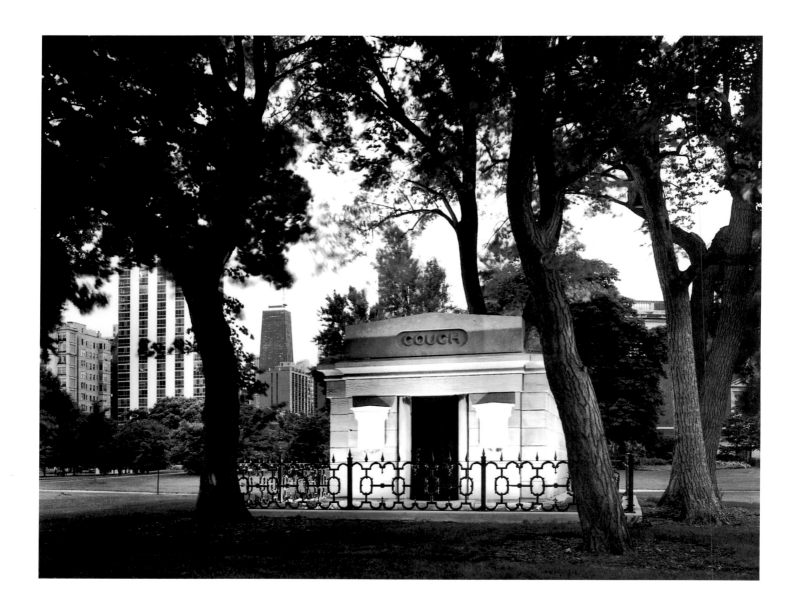

LINCOLN PARK BEGAN AS A LAKESIDE PUBLIC CEMETERY where victims of cholera and small pox were buried in shallow graves. In response to a public health threat, citizens demanded that the cemetery be transformed into a pleasure ground. Originally known in 1860 as Lake Park, the site was renamed Lincoln Park shortly after the assassination of Abraham Lincoln (1809–1865), 16th president of the United States. The city appropriated $10,000 for improvements and hired Swedish-born landscape gardener Swain Nelson to create an original plan. The site's early construction included interlinking artificial lakes, on which mute swans floated. In 1869, Lincoln Park was expanded to the north and south, and as part of this effort bodies were exhumed and transferred to other cemeteries. At the northern part of this expansion, the Lincoln Park Commission excavated North Pond, using the sandy dredge material to form an adjacent hill called Mount Prospect during the early 1880s.

After suffering severe storm damage during the winter of 1885, the commissioners began to build a breakwater system that also allowed for expansion of the park's acreage through landfill. This eastern extension included the creation of a long water course for rowers, known as South Lagoon. The next major landfill expansion effort began in 1904 under the direction of Ossian Cole Simonds, who then served as consulting landscape gardener. Simonds worked closely with Prairie School architect Dwight H. Perkins, whose notable work in Lincoln Park includes Café Brauer.

During the late 1930s, after the Lincoln Park Commission was consolidated into the Chicago Park District, the Works Progress Administration funded substantial improvements to the park, among these a major landscape extension and re-design of an old Victorian Lily Pool by landscape architect Alfred Caldwell. During the 1930s, in-house architects also designed notable bridges, comfort stations, and beach houses, including the Art Moderne style North Avenue Beach House. This was recently replaced with a new structure designed by Wheeler Kearns Architects, which, like the original, emulates a lake ship steamer.

Lincoln Park's final landfill extension during the 1950s brought its size to 1,208 acres. The largest park in Chicago, this linear landscape includes six bathing beaches, three boating harbors, a golf course and driving range, dozens of sculptures and monuments, a conservatory and gardens, the Chicago Historical Society, and numerous other cultural and recreational features.

Lincoln Park's sole above-ground reminder of its earlier history as a cemetery, the Couch Tomb, was constructed in 1857 as the family mausoleum of the owners of the Tremont Hotel. A generous gift from the Elizabeth Morse Charitable Trust recently funded repairs to the tomb, new lighting, and reconstruction of its ornamental iron fencing. (Summer, 2000. J.B.)

Grandmother's Garden,
also known historically as
the Old English Garden,
has flourished in Lincoln
Park since the early 1890s.
(Spring, 2000. J.I.)

Located at the north end of Grandmother's Garden, the William Shakespeare monument was bequeathed to Lincoln Park by railroad magnate Samuel Johnson. Sculptor William Ordway Partridge, who studied hundreds of portraits and busts of the Bard of Avon, won a competition for this commission. The monument was installed in 1894. (Spring, 2000. J.I.)

Lincoln Park's premier Prairie style structure, Café Brauer, was constructed in 1908, replacing an earlier South Pond refectory. After it had fallen into a terrible state of disrepair, the building was restored in 1989 through a cooperative effort between the Park District, the Zoological Society, and the Levy Organization. The facility now includes a concession and the magnificent Great Hall, which is available for rental for weddings and other special events. (Fall, 2000. J.B.)

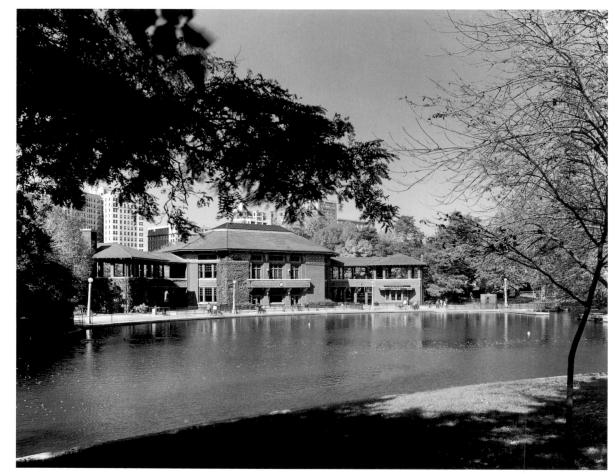

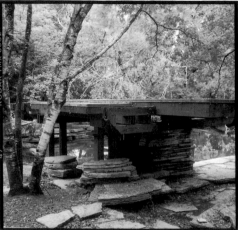
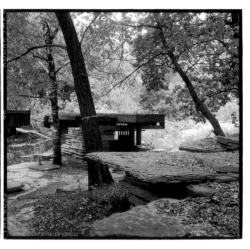

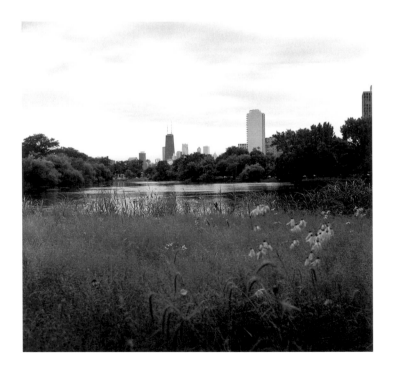

The recent restoration of Lincoln Park's North Pond includes prairie plantings along the water's edge. Thompson Dyke & Associates served as the consulting landscape architects. (Summer, 2000. J.B.)

The Lily Pool, once called the Zoo Rookery, has recently been renamed in honor of its designer, Alfred Caldwell. The Park District and Friends of Lincoln Park commissioned landscape architects Wolff Clements and Associates to undertake a $2.5 million restoration of this intimate reflecting pond and hidden landscape. (Fall, 2000. J.I.)

Lincoln Park's expansion during the late 1930s included a landfill to create the North Avenue Beach, a popular destination for swimmers and sunbathers, and the city's most well-used volleyball location, with more than 100 courts available each summer. (Summer, 2000. J.B.)

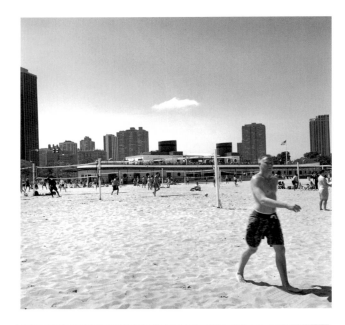

After the original 1930s North Avenue Beach House fell into disrepair, the Park District during the 1990s replaced it with a new structure. The new North Avenue Beach House was inspired by an original Art Moderne style building, designed to emulate a lake ship steamer. (Winter, 2001. J.B.)

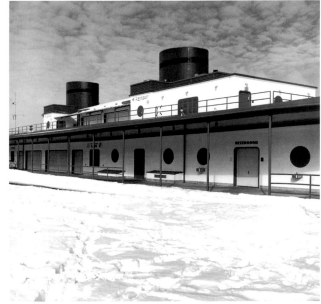

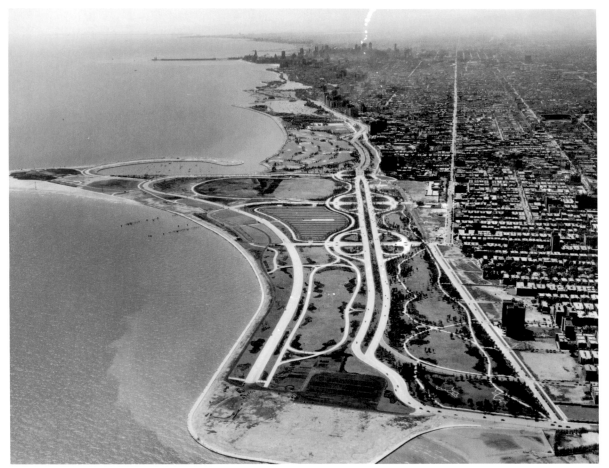

AT MORE THAN 300 ACRES IN SIZE, Marquette Park is the largest of the revolutionary neighborhood parks created by the South Park Commission during the early twentieth century. It pays tribute to Father Jacques Marquette (1637–1675), the famous French Jesuit missionary and explorer.

In 1904, the Olmsted Brothers developed an impressive plan for the park with a golf course on two islands surrounded by naturalistic lagoons, indoor and outdoor gymnasiums, swimming and wading pools, a children's playground, formal gardens, and a concert grove. Due to drainage problems and the site's large size, however, Marquette Park's improvements occurred slowly, often deviating from the original plan. Despite this, the commissioners did construct an 18-hole golf course on two large islands in the center of the park surrounded by a meandering waterway.

After establishing the golf course and a nursery of nearly 90,000 trees and shrubs, the commissioners converted frame houses and outbuildings that had previously existed on the site to park uses such as a warming shelter for skaters and a small field house. By 1917, the park also included athletic fields, a children's playground, tennis courts, propagating houses for the nursery, and a large, classically designed golf shelter.

In 1934, Marquette Park became part of the newly consolidated Chicago Park District. Using federal relief funds through the Works Progress Administration, the Park District soon converted the golf shelter into a field house, built comfort stations, and developed a series of footbridges leading to the islands. Through public subscription in 1935, an Art Deco style monument commemorating Lithuanian-American aviators, Capt. Stephen Darius and Lt. Stanley Girenas, was installed in the park.

During the 1960s and 1970s, racial tensions ran high as African-Americans began to settle in the neighborhood surrounding the park. Hate groups rallied against integration, and activists responded by organizing fair housing campaigns and anti-racism marches. Today, the park serves as an important catalyst for harmony among its increasingly diverse community.

Originally constructed as a golf shelter during the mid-1910s, this structure was converted for use as Marquette Park's field house during the 1930s. It fronts onto the park's extensive lagoon. (ca. 1925. CPDSC.)

Marquette Park's lagoons are extremely popular for fishing. As part of an Urban Fishing Program, the Illinois Department of Natural Resources stocks this and 11 other park lagoons with blue gill in the spring and channel catfish in the summer. (Summer, 2000. J.I.)

The Darius-Girenas Monument, installed in 1935, honors two Chicago flyers of Lithuanian descent who died in a crash during a trans-Atlantic goodwill flight two years earlier. (Summer, 2000. J.I.)

Iₙ 1902, ONE YEAR AFTER the assassination of William McKinley (1843–1901), 25th president of the United States, the South Park Commission opened an experimental park, named in his honor, which proved to be a nationally important prototype. Aware that vast numbers of Chicagoans had little access to the existing parks, during the late 1890s Superintendent J. Frank Foster and the South Park commissioners began to discuss the need for new parks to serve the overcrowded tenement neighborhoods in the center of the city. A state law approved in 1899 allowed the commissioners to acquire land for new parks. The following year, they purchased a 34-acre site near the Union Stock Yards. Composed of open prairie and cabbage patches, the site had previously been the Brighton Park Race Track.

In 1901, in-house South Park Commission architects created a plan for McKinley Park, which incorporated ballfields, playgrounds, open-air gymnasiums, a swimming lagoon, and a building with changing rooms and bathrooms. More than 10,000 people attended the park's dedication on 13 June 1902. The effort was so successful that the following year the South Park Commission began planning a whole system of new neighborhood parks for South Side. Opened to the public in 1905, the first 10 were Sherman, Ogden, Palmer, Bessemer, and Hamilton parks, and Mark White, Russell, Davis, Armour, and Cornell squares.

McKinley Park received such intensive use that in 1906 the South Park Commission acquired adjacent property, doubling its acreage. Improvements included a field house, standard swimming pool, and enlargement of the lagoon as a naturalistic design feature. McKinley Park's historic lagoon is one of a dozen Park District waterways stocked with fish through the state's Urban Fishing Program. The lagoon recently underwent a substantial rehabilitation project. McKinley Park also has a new interactive children's water feature, a permanent ice skating rink, recent tree, shrub, and floral plantings, and paving and fencing improvements.

Originally created as a swimming pool, McKinley Park's lagoon was extensively enlarged when the park's acreage was increased in 1906. The Park District restored the lagoon during the mid-1990s. (Summer, 1995. J.I.)

When McKinley Park opened to the public in 1902, it included the first swimming facility in the South Park System. Although this was a naturalistic swimming lagoon edged by sand, it inspired the construction of standard pools in the revoluntionary neighborhood parks, built two years later. (ca. 1905. CPDSC.)

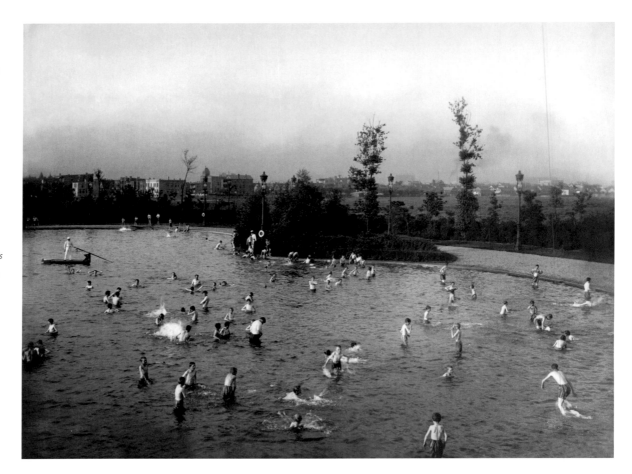

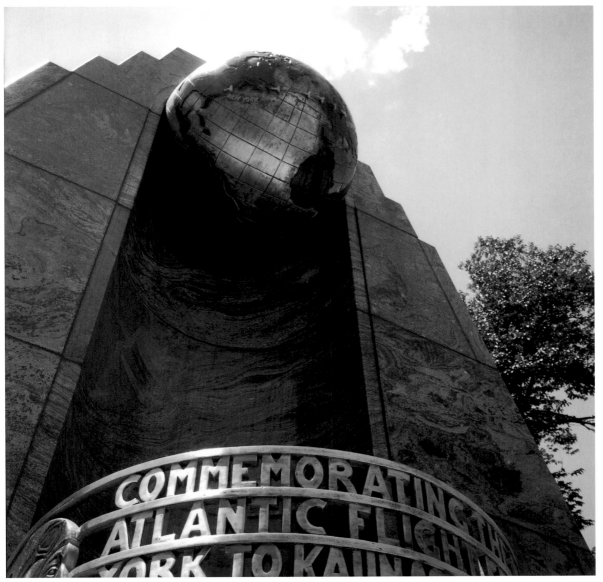

The Darius-Girenas
Monument, installed in
1935, honors two Chicago
flyers of Lithuanian descent
who died in a crash during
a trans-Atlantic goodwill
flight two years earlier.
(Summer, 2000. J.I.)

COMMEMORATING THE
ATLANTIC FLIGHT
YORK TO KAIN

Originally created as a swimming pool, McKinley Park's lagoon was extensively enlarged when the park's acreage was increased in 1906. The Park District restored the lagoon during the mid-1990s. (Summer, 1995. J.I.)

In 1902, ONE YEAR AFTER the assassination of William McKinley (1843–1901), 25th president of the United States, the South Park Commission opened an experimental park, named in his honor, which proved to be a nationally important prototype. Aware that vast numbers of Chicagoans had little access to the existing parks, during the late 1890s Superintendent J. Frank Foster and the South Park commissioners began to discuss the need for new parks to serve the overcrowded tenement neighborhoods in the center of the city. A state law approved in 1899 allowed the commissioners to acquire land for new parks. The following year, they purchased a 34-acre site near the Union Stock Yards. Composed of open prairie and cabbage patches, the site had previously been the Brighton Park Race Track.

In 1901, in-house South Park Commission architects created a plan for McKinley Park, which incorporated ballfields, playgrounds, open-air gymnasiums, a swimming lagoon, and a building with changing rooms and bathrooms. More than 10,000 people attended the park's dedication on 13 June 1902. The effort was so successful that the following year the South Park Commission began planning a whole system of new neighborhood parks for South Side. Opened to the public in 1905, the first 10 were Sherman, Ogden, Palmer, Bessemer, and Hamilton parks, and Mark White, Russell, Davis, Armour, and Cornell squares.

McKinley Park received such intensive use that in 1906 the South Park Commission acquired adjacent property, doubling its acreage. Improvements included a field house, standard swimming pool, and enlargement of the lagoon as a naturalistic design feature. McKinley Park's historic lagoon is one of a dozen Park District waterways stocked with fish through the state's Urban Fishing Program. The lagoon recently underwent a substantial rehabilitation project. McKinley Park also has a new interactive children's water feature, a permanent ice skating rink, recent tree, shrub, and floral plantings, and paving and fencing improvements.

When McKinley Park opened to the public in 1902, it included the first swimming facility in the South Park System. Although this was a naturalistic swimming lagoon edged by sand, it inspired the construction of standard pools in the revolutionary neighborhood parks, built two years later. (ca. 1905. CPDSC.)

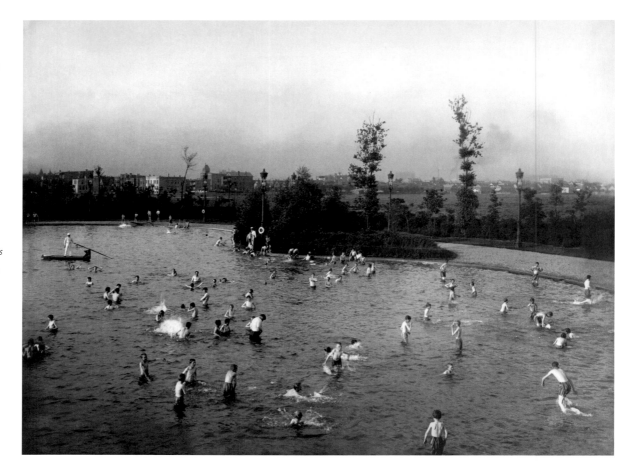

Once the home of Irish, German, and Polish immigrants, the McKinley Park community now includes many Mexican residents. The park continues to serve its working-class neighborhood as a refuge from the busyness of the city. (Summer, 1996. J.I.)

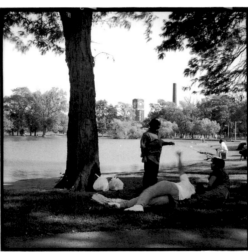

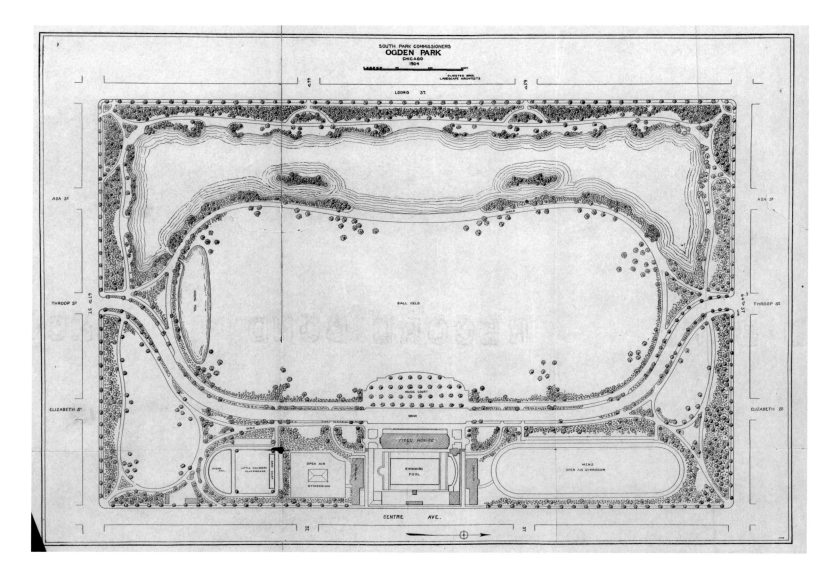

SOUTH PARK COMMISSIONERS
OGDEN PARK
CHICAGO
1904

OLMSTED BROS.
LANDSCAPE ARCHITECTS

Named for William B. Ogden (1805–1877), Chicago's first mayor, Ogden Park was among the South Park Commission's first 10 revolutionary neighborhood parks that opened to the public in 1905. Incorporating all of the program elements that the commission had conceived for these neighborhood parks, the Olmsted Brothers and D. H. Burnham & Company created a unique design for each project. Despite differences, Ogden Park shared design traits with nearby Sherman Park. Both parks were 60 acres in size, both had a beautiful landscape with a meandering waterway near a meadow of ballfields, and both boasted classical architecture. Ogden's naturalistic lagoon flowed into a smaller, oval-shaped, toy boat basin that was extremely popular during the 1920s. Its field house, though also classically inspired, was constructed of brick instead of the exposed aggregate concrete more commonly used by Edward H. Bennett for the other neighborhood park architecture designed by the Burnham firm.

Over the years, Ogden Park underwent major alterations. In 1940, its waterway was drained and filled to provide additional ball fields, and the oval-shaped boat basin was reconfigured into a circular pool for motorized toy boats. During the 1950s and 1960s, this pool was removed along with original features designed by the Olmsted Brothers such as the children's wading pool and sand courts. In 1972, the Chicago Park District remodeled the field house, erecting a new addition that sheathed the building in modern concrete facades, making the historic building unrecognizable. During the late 1990s, the Park District significantly improved Ogden Park by rehabilitating the swimming pool, reconditioning the athletic fields, planting new trees, shrubs, and gardens, and creating a new regional playground. One of the city's most exciting places for children, the Ogden Park playground includes assembly and stage areas, play equipment, an interactive water feature, and a canopied carousel, the only merry-go-round in Chicago's parks that is free to the public.

The original 1904 plan for Ogden Park by the Olmsted Brothers included a meandering lagoon and oval-shaped wading pool that was often used as a toy boat basin. Neither water feature exists today. (1904. CPDSC.)

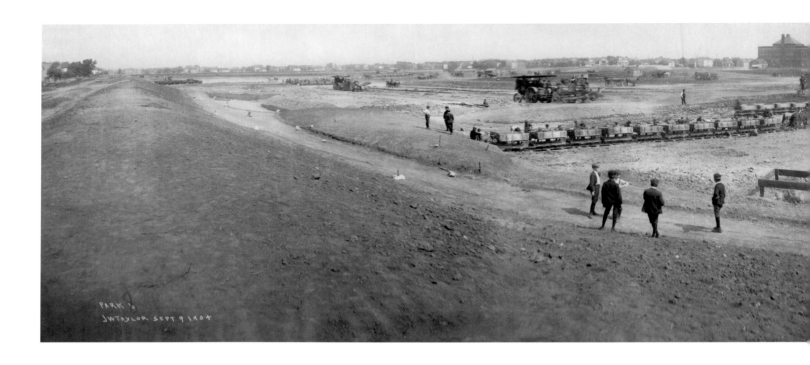

PARK ¹o
JWTAYLOR SEPT 9 1904

In 1904, when the South Park commissioners acquired the 60-acre site for Ogden Park, the neighborhood was composed of farmland interspersed with some homes and stores. The commissioners completed the park's construction and opened it to the public within a one-year period. (September, 1904. CPDSC.)

BELOW

This premier playground has brought new vitality to Ogden Park. Unique within the park system, it includes an interactive water-play feature, picnic areas, carousel, open-air performance area, and small gathering spaces for children's activities. (Summer, 2000. J.B.)

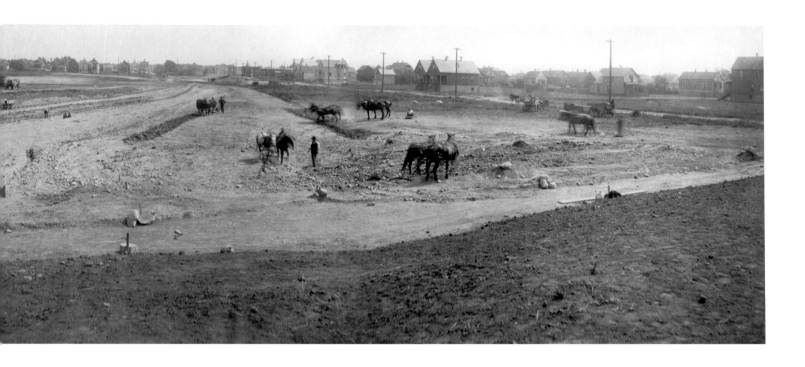

Today, Oz Park is located within one of Chicago's most fashionable neighborhoods. During the late 1950s and early 1960s, however, this North Side community suffered from urban blight. At that time, the Lincoln Park Conservation Association approached the City of Chicago in efforts to improve the area. By the late 1960s, the neighborhood had been designated as the Lincoln Park Urban Renewal Area. An urban renewal plan identified a 13-acre site for a new park, and in 1974 the Chicago Park District acquired the land.

In 1976, the park was officially named Oz Park in honor of Lyman Frank Baum (1856–1919), author of *The Wonderful Wizard of Oz*. Baum settled in Chicago in 1891 several miles west of what is now the park. At the age of 41, Baum began writing children's books. By the end of his life, he had authored more than 60 books, including 14 relating to the Oz theme. In 1939, the production of an MGM movie, *The Wizard of Oz*, immortalized Baum's classic work of fiction.

During the early 1990s, the Oz Park Advisory Council and the Lincoln Park Chamber of Commerce commissioned artist John Kearney to create a *Tin Man* sculpture. Community organizations recently installed a *Cowardly Lion* monument, also by Kearney. Other elements that celebrate Oz Park's theme include the "Emerald Garden" and "Dorothy's Playlot." This existing playlot was renamed to honor Dorothy Melamerson, a retired local school teacher who bequeathed her life's savings to fund a number of park improvements in the Lincoln Park neighborhood. The Park District honored the 100th anniversary of the publication of Baum's book with "The Celebration of *The Wizard of Oz*." There were readings from the book by costumed characters as well as games and prizes.

Although Oz Park has no field house, the Chicago Park District and Board of Education jointly sponsor indoor programs out of the adjacent Lincoln Park High School. The school uses the park for all of its outdoor athletic training and games, and the CPD uses the school for programs such as basketball and vollybal league games at night. Other programs in Oz Park include outdoor movies during the summer and a pumpkin patch in autumn.

The "Tin Man" sculpture and "Dorothy's Playlot" are two of several elements that celebrate the Oz theme. During the late 1980s, designer Robert Leathers incorporated ideas from local children into his scheme for this playlot. (Summer, 2000. J.I.)

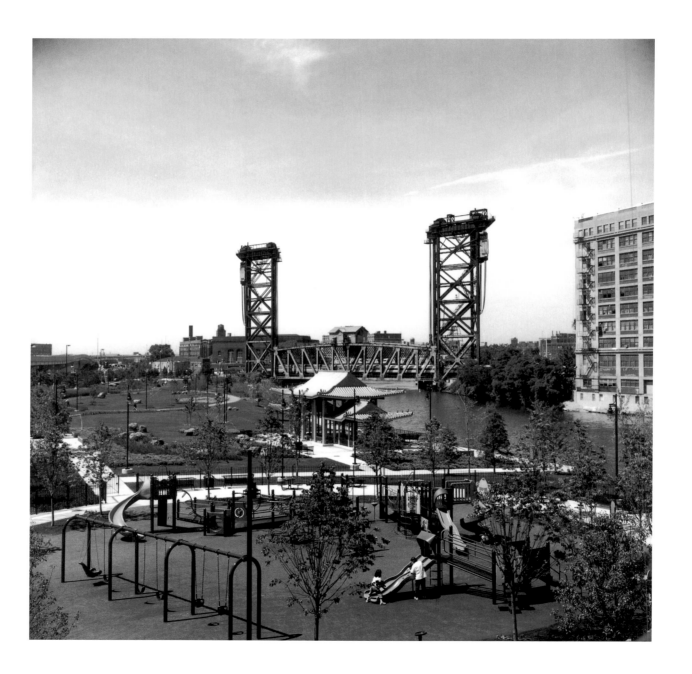

THE CHICAGO PARK DISTRICT ACQUIRED THE SITE for Ping Tom Memorial Park in 1991. For years, its surrounding Chinatown community had suffered from a lack of open space and recreational facilities. The closest adjacent parks, Hardin Square and Stanford Park, had been demolished 30 years earlier to make way for the Dan Ryan Expressway. Two full generations of children in Chinatown grew up with little access to parks or other recreational areas.

Ping Tom Memorial Park's 12-acre site was originally a Chicago and Western Indiana Railroad yard located along the edge of the South Branch of the Chicago River. Adjacent to the site is the South Branch Chicago River Bridge. Built in 1915, this 195-foot tall, vertical lift bridge carries passenger and freight trains southbound out of Chicago. By the early 1970s, the railyard had closed. The rails were removed and the site remained vacant until the CPD acquired it. In 1998, the Park District began transforming the site into a beautiful, rolling green space, taking full advantage of impressive river views. The award-winning project includes a children's playground, community gathering areas, and elements of Chinese landscape design.

The park's name honors the leading force behind its creation, Ping Tom (1935–1995), a life-long Chinatown resident. In 1984 Ping Tom formed the Chinese American Development Corporation, a real estate firm that transformed 32 acres of railyard into a $100 million residential and commercial expansion of Chinatown. Active in numerous prominent civic and cultural institutions, Ping Tom was also an advisor to U.S. senators, Illinois governors, and Chicago mayors.

A collaborative effort between the Park District, Chinatown community, and Chinese-American landscape architect Ernest Wong, of Site Design Group, the new Ping Tom Memorial Park includes an entry plaza, riverfront pavilion, playground, and gardens. (Spring, 2000. J.I.)

LOCAL CITIZENS FORMED the Old Portage Park District in 1912 to enhance property values and improve their Northwest Side neighborhood. The following year, the board acquired land and hired the American Park Builders Company to create a plan for the district's first and largest park. Both the district and the park were named in honor of an early portage route used by American Indians and fur traders to navigate their canoes between the Chicago and the Des Plaines rivers.

Constructed between 1913 and 1917, Portage Park originally included a naturalistic swimming lagoon. By the 1920s, the new park was thriving. Noted architect Clarence Hatzfeld designed a handsome Prairie style field house in 1922, followed by an attractive brick gymnasium in 1928. Portage Park quickly became the center of the community, providing athletics and team sports, cultural and club activities, festivities, and special events.

In 1934, when the city's 22 independent park commissions were consolidated into the Chicago Park District, the new agency began to improve Portage Park, including additional plantings, whimsical stonework fountains and gateways, and a comfort station. CPD workers, hired through the Works Progress Administration, also removed the original swimming lagoon and constructed a kidney-shaped concrete pool. In 1959, the Park District replaced the concrete pool with an Olympic sized pool in preparation for hosting the Pan American Games. In 1972, Portage Park hosted the U.S. Olympic swimming trials, where gold medalist Mark Spitz set new world's records.

Today, the original field house is a cultural center, offering arts and crafts, drama, music, and senior citizens programs. Recent improvements to Portage Park include the rehabilitation of the swimming pools and plaza area and the installation of an interactive water play area for children. New gardens in the park attract birds, butterflies, and people. Other popular attractions at Portage Park include an in-line roller hockey rink and a well-used woodshop facility.

For years, Portage Park has featured one of Chicago's premier aquatic centers. In addition to indoor and outdoor swimming pools, the park now has an interactive water play area for young children. (Summer, 2000. J.B.)

This pool, created by the Park District during the 1930s, no longer exists, although similar stone details still abound in the park. (April, 1938. CPDSC.)

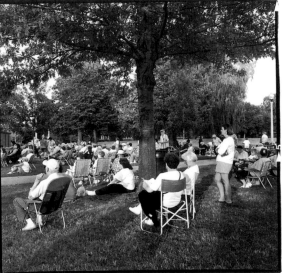

Portage Park is one of more than 40 parks throughout the city to offer free musical entertainment through Concerts in the Parks, a program that started in 1947. The Park District, in conjunction with the Chicago Federation of Musicians and the Recording Industry's Music Performance Trust Fund, sponsors this initiative. (Summer, 2000. J.B.)

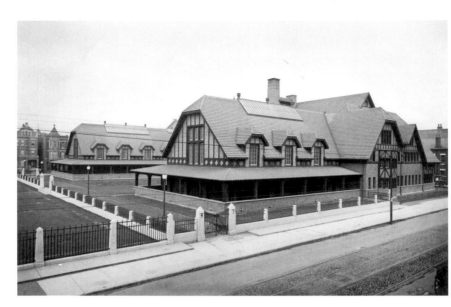

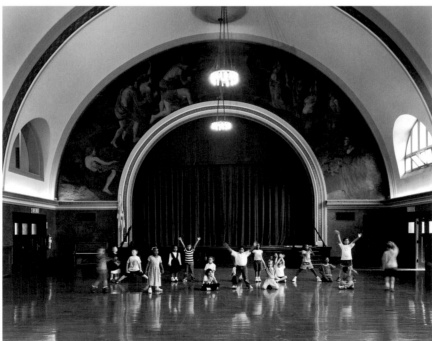

Inspired by the success of the innovative South Side neighborhood parks, the West Park Commission began creating three new small parks to serve the densely populated immigrant communities within its jurisdiction in 1907. Five years later, the commission identified sites for several additional parks, including a 3.8-acre parcel in West Town, a crowded, predominantly Polish neighborhood of factories and workers' housing. To make way for the park, the West Park Commission displaced 1,200 people, demolished some buildings, and moved others to nearby locations in the neighborhood. After filling the low site, the commission began making improvements conceived by Jens Jensen, who then served as consulting landscape architect.

The Pulaski Park field house and swimming facility were begun in 1912 and completed in 1914. Incorporating elements such as tile roofs, half-timbering, a tower, dormers, and verandahs, architect William Carbys Zimmerman designed the three-story brick field house to emulate Eastern European architecture familiar to the immigrant community. The building's interior also includes lovely details. An impressive mural designed by James J. Gilbert and painted by his students from the School of the Art Institute of Chicago in 1920 adorns the auditorium's proscenium. A second mural, hidden in the upper tower room, portrays Polish themes. An arts and crafts class painted this during the late 1930s.

The park pays tribute to Casimer Pulaski (ca. 1748–1779), a Polish war hero who fought for the American cause during the Revolutionary War and who died in action at the Battle of Savannah. Over the years, Mexican and Puerto Rican immigrants and young urban professionals have replaced the area's predominance of Polish immigrants. Despite these demographic shifts, the Chicago Park District continues to offer programs that are beneficial to the surrounding community. For instance, through a partnership with Malcolm X College, Pulaski Park provides general education degree classes in Spanish and English. Also the site of one of several Arts Partners in the Parks programs, Pulaski Park houses the Free Street Theater troupe, which provides students with training in the performing arts.

When it was constructed between 1912 and 1914, the architecturally eclectic Pulaski Park field house was one of the largest year-round park facilities in Chicago. (1914. CPDSC.)

The large and beautiful auditorium in the Pulaski Park field house, with its vaulted ceiling and proscenium mural, is used for a variety of purposes today, including gymnastic classes, theatrical events, and community programs. (Summer, 2000. J.B.)

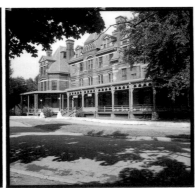

PULLMAN AND ARCADE are the two parks donated to the Town of Pullman by its founder, George M. Pullman (1831–1899). Having vastly improved the comfort of long distance rail travel by creating the luxurious sleeping cars that bore his name, Pullman began planning his own industrial town during the 1870s. He purchased 3,500 acres on the western shore of Lake Calumet, then outside of Chicago, to build his new factory, worker housing, stores, churches, and public buildings. Envisioning a beautifully designed town as the solution to potential labor tensions, Pullman hired architect Solon S. Beman and landscape architect Nathan F. Barrett to create his renowned company town. By 1884, the Town of Pullman had around 8,000 residents.

Beman designed a series of eclectic, brick residential buildings, ranging from "model tenements" to workers' row houses, and large detached homes for the company's high-level employees. He also created factory buildings, a church, railroad station, school, and the Arcade, an enormous structure with shops, post office, library, and theater. Barrett, who had designed the grounds for George Pullman's New Jersey estate during the 1870s, was responsible for siting all of the Town of Pullman's buildings, laying out and planting its streets, and designing all of its landscapes. Barrett sited the gardenesque Arcade Park adjacent to the impressive brick, iron, and glass structure. Although the building was demolished in 1926, the park still exists. Its fanciful gardens are no longer intact, but the oval configuration of its walkways and its context next to historic brick buildings remain.

The City of Chicago acquired Pullman and Arcade parks in 1909. Fifty years later, the two adjacent properties were transferred to the Chicago Park District. In 1977, new paving, plantings, and period lighting and benches were installed in Arcade Park. In recent years, the Arcade Park Garden Club has taken responsibility for planting and maintaining floral beds in both parks.

Named for the U.S. Army's 42nd Rainbow Division that fought so gallantly in World War I, Rainbow Beach Park began as two separate municipal beaches. The Special Parks Commission established the first one in 1908. Located at 79th Street and Lake Michigan, this 3.5-acre site was known as Rocky Ledge Beach. Its name referred to the area's rocky terrain, and to the human-made limestone ledge that both served as a shoreline promenade and provided protection from shoreline erosion. By 1912, the heavily used beach had bathrooms and changing rooms. Illuminated by electric lights, the beach remained open until 9:30 p.m. for the benefit of working men and women.

In 1914, the city began efforts to expand the beach. Riparian rights were secured and two years later the city acquired land between 75th Street and Rocky Ledge Beach. The City Council officially named the new site Rainbow Beach in 1918. By the 1920s, the new beach had bathrooms and changing rooms, an athletic field, and a pond used for skating in the winter. The smaller, adjacent Rocky Ledge Beach continued to operate as a children's beach. During World War II, area residents planted Victory gardens, which are still maintained as community gardens.

The two beaches were consolidated in 1959, when the Chicago Park District began leasing the site from the city. For many years the park lacked sufficient indoor recreational facilities, so in 1999 a field house and beach house complex was constructed. Designed by David Woodhouse Architects, the structures take full advantage of the park's great views of the lakefront and skyline. A long-time popular site for festivals, community picnics, and family reunions, Rainbow Beach Park now also offers many new year-round programs, thanks to its new building, the newest field house in Chicago's park system.

Rainbow Beach Park's new field house and beach house have provided long-needed facilities to the south lakefront. These structures reflect a very contemporary style and provide year-round programs and summer beach facilities, including lifeguard station, concession, bathrooms, and foot sprays. (Spring, 2000. J.B.)

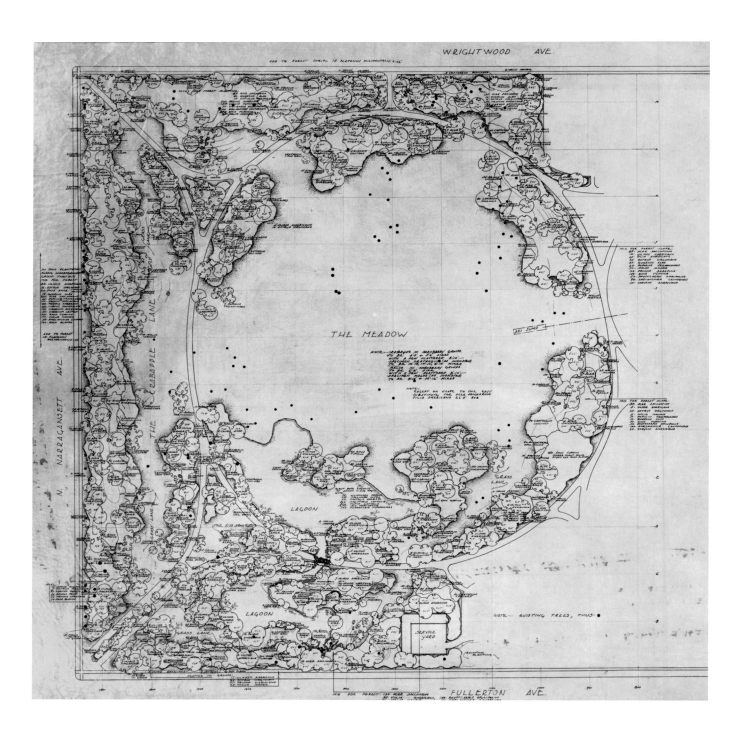

RIIS PARK

PHOTOJOURNALIST AND REFORMER Jacob A. Riis (1849–1914), of New York City, drew national attention to the plight of the inner-city poor through his exposé, *How the Other Half Lives*. In 1898, as a guest of the Municipal Science Club, Riis made a passionate speech at Chicago's Hull House, advocating the creation of playgrounds and small parks for the children of the tenement districts. This soon inspired the formation of the Special Park Commission and creation of some of Chicago's earliest playgrounds and neighborhood parks. By the time Chicago's Northwest Park District created Riis Park in 1916, the reformer's advocacy efforts had helped to fuel park building across the nation. By this time, neighborhood parks were not only a vehicle of social reform, but also a valued asset within the most stable communities.

Acquiring the mostly unimproved 55-acre site, which included a dramatic glacial ridge, the Northwest Park District intended to provide a broad range of recreational amenities within Riis Park. Despite this, little work took place until residents repeatedly petitioned the park board during the 1920s. Finally in 1928, the Northwest Park District installed a ski jump and golf course and commissioned locally prominent architect Walter W. Alschlager to design a Georgian Revival style field house.

In 1934, the Northwest Park District was consolidated into the Chicago Park District, which used Works Progress Administration funds to complete Riis Park. At the site's western side, in which the steep ridge is located, landscape architect Alfred Caldwell created a beautiful, passive landscape in which he incorporated naturalistic plantings, a stone-edged lagoon, shady enclosed areas, and a broad, sunny meadow. Below the ridge, to the east, the golf course was removed and ball fields, tennis courts, running track, children's playground, and swimming pool complex were constructed, completing the park by 1940. Recent initiatives by the CPD include a new interactive water feature, restoration of the lagoon, new trees, shrubs and floral plantings, and lighting, paving and fencing improvements.

In his plan for the western half of Riis Park, Alfred Caldwell created a great open meadow and meandering crabapple lane with masses of native vegetation. His design also included a naturalistic lagoon edged by slabs of stratified stonework. (20 August 1936. CPDSC.)

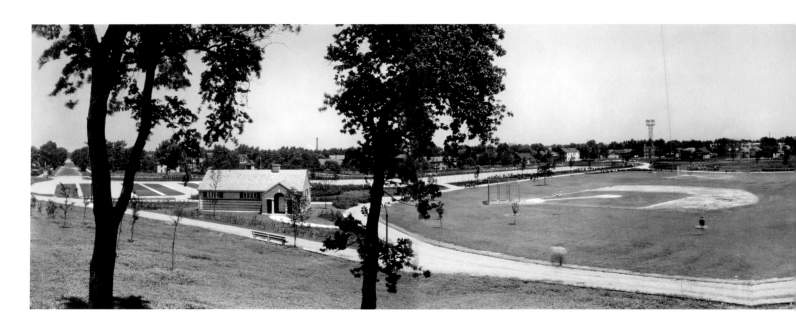

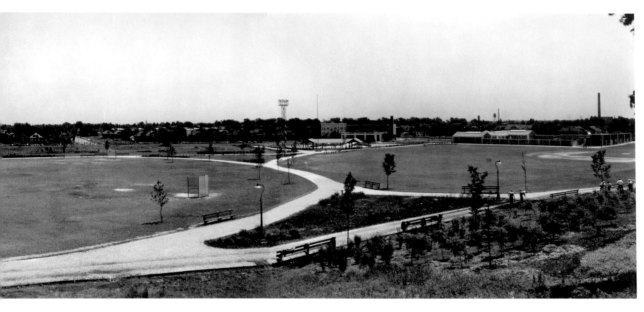

Chicago Park District laborers had nearly completed improvements to Riis Park when this panoramic photograph was taken. Their efforts included the removal of a nine-hole golf course and its replacement with ball fields, tennis courts, running track, playground, and swimming complex. (ca. 1937. CPDSC.)

BELOW

Riis Park continues to provide a large array of active and passive uses to the surrounding community. The site's natural ridge is popular for bicycling in summer and sledding in winter. (Summer, 2000. J.I.)

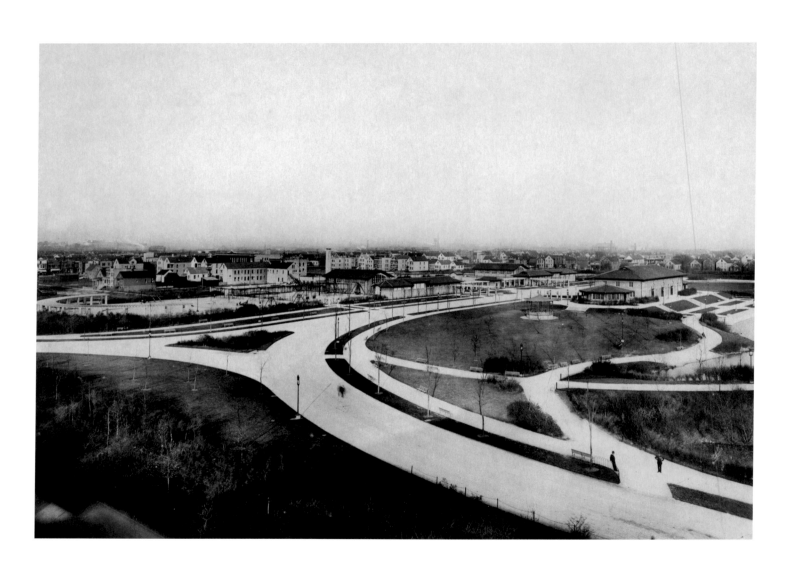

SHERMAN PARK IS THE LOVELIEST and most restored of the first 10 neighborhood parks that were designed by the Olmsted Brothers and D.H. Burnham & Company in 1904. Due to the relatively large 60-acre site and its low and wet conditions, the Olmsted Brothers determined that the plan should include a waterway that would loop around most of the landscape. Although they originally envisioned this as a formal canal, configured as a rectangular form and built with concrete walls, the South Park commissioners were concerned that this scheme was too expensive and would not provide adequate space for ball fields, so they asked the Olmsted Brothers to prepare a revised plan. The result was a naturalistic island of ball fields surrounded by a meandering lagoon, with irregular masses of trees and shrubs.

The formal design idiom was expressed only at the northern end of the park, in which its architectural complex was located. Here, the architects created a separate field house on one side of the park's circuit drive, and a men's and women's gymnasium and locker room complex flanking an outdoor swimming pool on the other side. To unify the various aspects of the buildings, D.H. Burnham & Company included a series of trellis-like pergolas. This architectural commission was especially meaningful to Burnham, because the park was named for his father-in-law, John B. Sherman (1825–1902), founder of the nearby Union Stock Yards who served as a South Park commissioner for 25 years.

During the late 1930s, the Chicago Park District demolished the original pergolas and modified the remaining buildings in an unsympathetic manner. Major, recent restoration efforts have reversed that trend, among them replacing the original, green ceramic Spanish tile roof, rebuilding overhanging eaves, reconstructing the missing pergolas, and matching the original window details. Additional work has focused on upgrading Sherman Park's lagoon and re-planting its landscape.

The most formally designed section of Sherman Park is the north end of the landscape, which includes its magnificent architectural complex. This photograph also reveals the historic relationship between the park and nearby cottages and tenement buildings. (ca. 1906. CPDSC.)

Historically, the Sherman Park field house had a grand terrace that provided beautiful views of the park and an area from which to launch boats into the lagoon. (ca. 1935. CPDSC.)

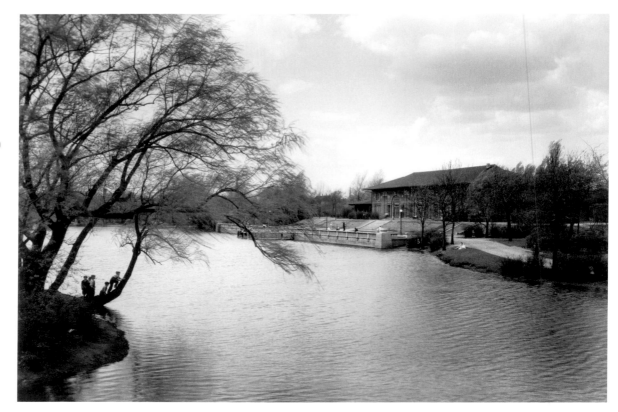

Sherman Park has four historic bridges that cross its lagoon to the ball fields on the island. The two bridges at the north end, located near the park's architectural complex, have a smooth finish, and the two at the south end have a rustic finish relating to the more naturalistic landscape. (Summer, 1995. J.I.)

The Park District recently undertook a major construction project by which the gymnasium and locker room buildings were restored, a 1940s blank-faced wall was removed, and the historic lifeguard building and attached pergolas were reconstructed. Just north of the park is the St. John of God Church, constructed in 1920. (Summer, 2000. J.B.)

Historically, trellis-like pergolas helped not only to create unity between Sherman Park's various buildings, but also to relate the architecture to the landscape. The original pergolas were razed during the late 1930s. (ca. 1910. CPDSC.)

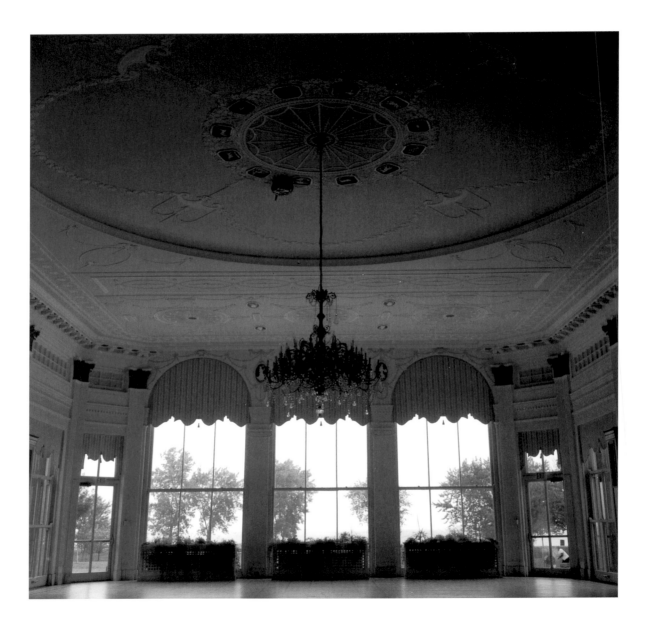

SOUTH SHORE CULTURAL CENTER

THE SOUTH SHORE CULTURAL CENTER, a 65-acre park with a golf course, tennis courts, bathing beach, and an enormous building, originated as the private South Shore Country Club. In 1905, Lawrence Heyworth, president of the downtown Chicago Athletic Club, envisioned an exclusive club with a "country setting." Heyworth selected a south lakefront site often used by fishermen and duck hunters for the new enterprise.

The club's directors hired architects Marshall and Fox, later known for designing many of Chicago's most luxurious hotels and apartment buildings. For inspiration, Heyworth provided a photograph of an old private club in Mexico City, but asked the architects to exclude expensive embellishments. As the club could not yet collect dues, work had to proceed quickly and inexpensively. To help out, club members Marshall Field and A. Montgomery Ward lent their store delivery wagons to transport turf, sod, and trees.

Enjoying immediate success and social importance, South Shore Country Club quickly outgrew its facilities. Marshall and Fox soon designed a new club house, incorporating the original ballroom. Constructed in 1916, the larger and more substantial Mediterranean Revival style building resembled the original. The country club's membership peaked during the late 1950s, a period in which African-Americans began settling in the South Shore neighborhood. Because the private club excluded black members, it went out of business during the 1970s.

In 1974, the Chicago Park District purchased the property to expand its lakefront facilities. Although the Park District planned to demolish the severely deteriorated club house, community members rallied together to save the historic building. Rehabilitating the club house as a cultural center during the late 1970s, the CPD has since restored other historic features, including the front colonnade, entry gate, and stables, and developed the site as a cultural center. Today, South Shore Cultural Center is one of the city's most popular facilities for weddings and special events, and it serves as a mecca for exhibits, concerts, and other artistic endeavors. Its beach, nine-hole golf course, and nature area are also popular.

The Solarium and two other elegant rooms in the South Shore Cultural Center are popular for rental for weddings, parties, and other special events. The windows overlook the park's beach and are adjacent to its nine-hole golf course. (Summer, 2000. J.L.)

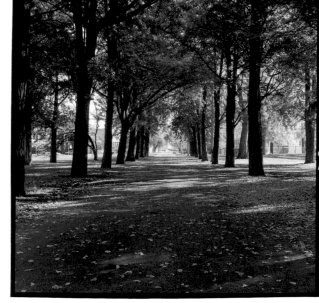

Trumbull Park's gingko
trees, formally planted as
an allée, turn flaming yel-
low in autumn. (Fall,
2000. J.L.)

THE SOUTH PARK COMMISSION began to create Trumbull Park in 1907, two years after its first neighborhood parks opened to the public. Initially including Russell, Mark White, Davis, Armour, and Cornell squares, and Bessemer, Ogden, Sherman, Palmer, and Hamilton parks, the system was an immediate success. By 1907, the commissioners were attempting to complete eight new parks: four that had been delayed when the first 10 opened and four additional parks. One of the areas targeted for a new park was South Deering, then known as Irondale for its proximity to a large steel mill complex. The South Park Commission acquired 18.5 acres adjacent to the densely populated tenements. (These were replaced in 1936 by a Chicago Housing Authority project known as Trumbull Park Homes.)

The South Park Commission hired the Olmsted Brothers, landscape designers of the previous neighborhood parks, to lay out the four new parks in 1910. The commissioners chose not to implement these plans; rather, they had in-house designers create a single plan for both Trumbull Park and nearby Grand Crossing Park. The plans differed only in that their orientation was reversed. Today, the two landscapes look somewhat different because only Trumbull Park retains a magnificent stand of gingko trees in its central plaza. The two parks do have identical, classically designed field houses that were constructed in 1914. The commissioners named this site to honor Lyman Trumbull (1813–1896), chief justice of the Illinois Supreme Court, U.S. senator, and active abolitionist.

During the Depression, the Chicago Park District offered a toy-lending library, game room, gymnastics, arts and crafts classes, play groups, and radio and mother's clubs in Trumbull Park's field house. Today, Trumbull Park is one of many sites offering PARK Kids programs, after-school activities for six- to 12-year-olds. The park also has a very popular basketball program geared to children between the ages of 10 and 13.

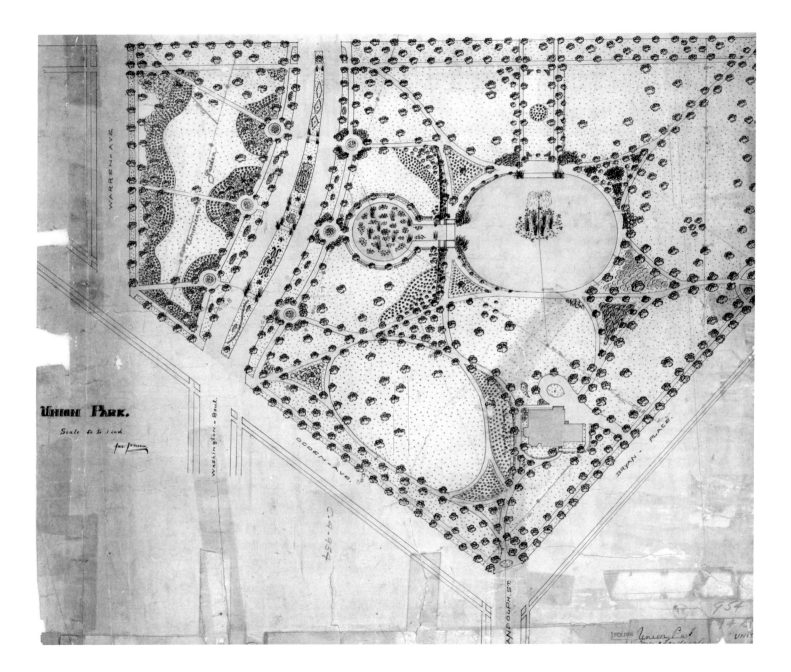

UNION PARK.

Scale 50 to 1 inch.

Jens Jensen

UNION
PARK

Union Park was created in 1853, after residents convinced developers to sell 13 acres of their subdivision to the city at a reduced price. Named for the Federal Union and improved with an artificial lake, rustic bridges, a zoo, and whimsical observation tower, the park was one of Chicago's most fashionable places. In 1885, the city transferred Union Park to the West Park Commission, which made the park its headquarters. Three years later, Jens Jensen, then serving as a gardener, planted the experimental *American Garden*, marking the beginnings of his venerable naturalistic style.

At the turn of the twentieth century, African-Americans began to move into the neighborhood. While many other parks were inaccessible to black residents, Union Park became racially integrated. When the Union Park natatorium and swimming pool complex was constructed in 1917, the commissioners distributed flyers in the community to advertise the availability of the new facility to the entire community. Although a terrible week-long race riot broke out on Chicago's South Side in 1919, Union Park remained harmonious.

By the 1920s, several professional African-American employees served as Union Park's staff, among them Mrs. Anna Walker, the music and drama director. In addition to organizing the highly successful annual West Chicagoland Musical Festival at Union Park, Mrs. Walker made the park the cultural mecca of the entire community. Notable musicians who performed at events in Union Park include gospel music pioneer Thomas A. Dorsey, trumpeter Sunny Cohn, and jazz pianist Ramsey Lewis.

Today, there is renewed interest in drama at Union Park, and the Chicago Park District's program offers classes in basic drama skills, staging, costumes, and set design. Participants are also encouraged to perform at various theaters throughout the city.

Interest in the park's history has encouraged the installation of a photo exhibit in the field house and native plantings on the site of the *American Garden*.

When Jens Jensen created this plan for Union Park, he signed it Jas. Jensen, an anglicized version of his name. Although the plan includes an hourglass shaped lily pool by William Le Baron Jenney, it also depicts Jensen's revolutionary American Garden, with an undulating lawn in the center defined by groups of transplanted wildflowers. (ca. 1890. CPDSC.)

Union Park was the cultural center of the West Side's African-American community. This was largely inspired by Mrs. Anna Walker, depicted here as conductor of Union Park's orchestra. (1935. CPDSC.)

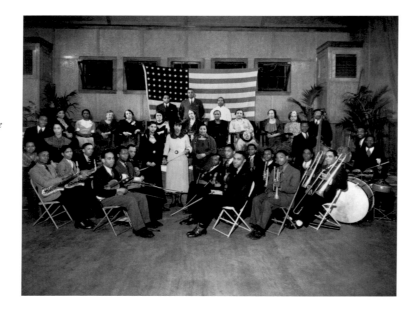

Once referred to by the Park District as "Our Broadway," today Union Park has renewed its theater arts program. The park offers classes in acting, theater, and the technical aspects of theater. (Fall, 2000. J.B.)

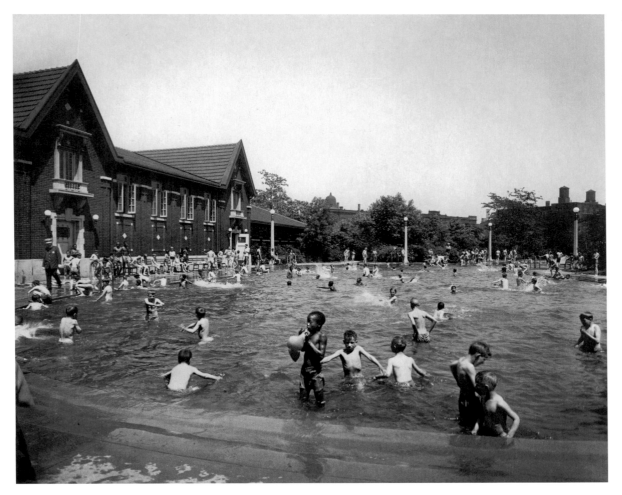

In 1920, 40 percent of Union Park's patrons were black and 60 percent were white, quite unusual for the time. (ca. 1920. CPDSC.)

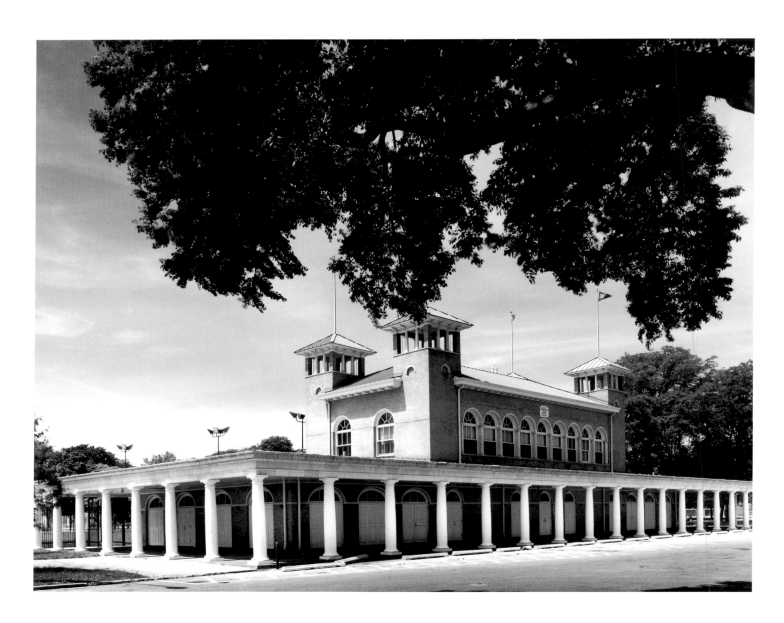

The Park District restored the stately Washington Park refectory during the early 1990s. Today, the building includes locker and changing rooms, offices, and rooms that can be used for meetings, parties, and other special events. (Summer, 2000. J.B.)

AFTER THE ILLINOIS STATE LEGISLATURE established the South Park Commission in 1869, the newly appointed board acquired more than 1,000 acres of land just south of Chicago for a large park and connecting boulevards. Originally called South Park, the park property was composed of eastern and western divisions and the Midway Plaisance, a wide boulevard connecting the two divisions. The western division was later renamed Washington Park in 1881 to honor George Washington (1732–1799), first president of the United States. The eastern division became known as Jackson Park.

Olmsted and Vaux published their ambitious plan for South Park in 1871. Later that year, Chicago's Great Fire caused the destruction of tax rolls and other legal documents related to the park commission. In response, the South Park Board hired Horace W. S. Cleveland, who had previously worked for Olmsted, to modify the park plan and oversee its implementation. By the late 1880s, more than two-thirds of Washington Park's acreage had been improved.

Olmsted's pastoral vision for Washington Park included rolling topography, a deer paddock, and the South Open Green, a great meadow on which sheep grazed and children played baseball. D. H. Burnham & Company designed three structures in the park. The oldest, a rustic, round stables building made of limestone, dates to 1880. The 1891 Roman-brick refectory provided space for parties, special events, and offices for the commissioners.

As the South Park Commission soon outgrew this office space, the Burnham firm designed the larger, classical administrative headquarters in 1910. After consolidation of the Chicago Park District in 1934, separate offices were no longer needed and the old administrative building was used as studio space for more than 100 Works Progress Administration artists. During the 1970s, this building was converted into the DuSable Museum of African-American History.

By the mid-1930s, the growing African-American community surrounding Washington Park was in dire need of additional recreational facilities. The Park District responded by building two competition-sized swimming pools and a wading pool near the old refectory building, which was adapted to provide shower and locker rooms. During the early 1990s, the CPD rehabilitated the structure and developed the swimming facility into a major aquatics center.

Olmsted and Vaux's genius
is well evidenced by their
design of Washington
Park's subtly contoured
landscape. Tucked behind
these berms is a hidden
waterfall northeast of the
lagoon. (Summer, 1996.
J.I.)

Adjacent to the refectory, the Park District constructed the system's premier aquatic center with an Olympic-sized swimming pool, diving and wading pools, and grandstands in 1936. During the early 1990s, this facility was rehabilitated and now includes a giant slide, interactive water fountains, and concessions. (Summer, 2000. J.B.)

In Lorado Taft's master-piece, Fountain of Time, 100 women, men, and children represent humanity's life-long struggle against time. After suffering severe deterioration over the years, the 1922 sculpture was recently conserved through a collaboration between the Art Institute of Chicago and the Park District. Children obviously are drawn to the sculpture. (Summer, 1995. J.I.)

IN 1842, THE AMERICAN LAND COMPANY, a speculator in real estate, donated a three-acre parcel to the city for use as a public park. The donors named the site Washington Square, possibly after a similar park located in an elegant New York City neighborhood. As the developers had hoped, many fine residences and churches soon surrounded the public square.

In 1869, the city began to improve Washington Square with lawn, trees, diagonal walks, limestone coping, and picket fencing. By the 1890s, an attractive fountain adorned its center. Within a decade or so, however, the fountain was razed and the park became dilapidated. In 1906, when Alderman McCormick became president of the city's Drainage Board, he decided to devote his aldermanic salary to site improvements. McCormick donated a $600 fountain, and the city allocated an additional $10,000 to rehabilitate the park. Jens Jensen, then a member of the city's Special Park Commission, created the plan for these landscape improvements.

By the 1910s, the neighborhood surrounding Washington Square had become more diverse. Because old mansions were converted into flophouses, the park earned the nickname, "Bughouse Square." Like Speakers' Corner in London's Hyde Park, Washington Square became a popular spot for soap box orators. Artists, writers, political radicals, and hobos pontificated, lectured, recited poetry, ranted, and raved. A group of regulars even formed "The Dill Pickle Club," devoted to free expression. For years Washington Square's orators appointed their own honorary "king." By the 1930s, "Bughouse Square" had such a colorful reputation that tour buses included it on sightseeing routes of Chicago.

In 1959, the city transferred Washington Square to the Chicago Park District. Although Alderman McCormick's fountain was removed in the 1970s, during the late 1990s the Park District, the city, and neighborhood organizations agreed on a restoration plan for Washington Square. Improvements include a reconstructed historic fountain, period lighting, fencing, benches, and new plantings.

Having been razed after nearly 70 years as Washington Square's centerpiece, the park's historic fountain was recently reconstructed. Today, the lovely, small square attracts daily strollers and picnickers and is the location of the Newberry Library's annual outdoor debates. (Summer, 2000. J.B.)

Edward H. Bennett (1874–1954). An architect who was classically trained at the Ecolé des Beaux Arts in Paris, Bennett met Daniel H. Burnham while working in the office of New York City architect, George B. Post. In 1903, Burnham "borrowed" Bennett to participate in a competition to design the military academy at West Point. The following year, Bennett accepted a position in the D.H. Burnham & Company firm. His first assignment was the architectural work for an innovative system of neighborhood parks for Chicago's South Park Commission. Bennett assisted Burnham on the 1906 *Plan of San Francisco*, one of the nation's first municipal plans, and also co-authored the 1909 *Plan of Chicago*. In 1913, Bennett was appointed as consulting architect for the Chicago Plan Commission. He also maintained a busy architectural office, which by 1922 was known as Bennett, Parsons, Frost, and Thomas. In addition to designing Grant Park and *A Century of Progress Fair* in Burnham Park in Chicago, Bennett produced plans for regions, cities, subdivisions, civic centers, and campuses throughout the nation.

Chicago Park District (CPD). Chicago's 22 independent park districts were consolidated into the Chicago Park District in 1934. When it was first formed, the CPD took over 5,337 acres of land, within a total of 134 existing parks in various states of improvement and repair. At that time the CPD also took control of 200 miles of the city's boulevards. In 1959, a second, functional consolidation act resulted in the transfer of all boulevards to the City of Chicago. In addition, more than 250 city-owned parks were transferred to the Park District and the park police force was consolidated into the Chicago Police Department. Today, the Chicago Park District, an agency with an annual budget exceeding $300 million, is responsible for more than 7,000 acres of land within 555 parks.

Daniel H. Burnham (1846–1912). One of Chicago's most famous architects and planners, Burnham helped inspire the City Beautiful Movement throughout the nation and world. In 1873, Burnham began an 18-year partnership with John Wellborn Root, and the two produced hundreds of buildings and contributed to the development of the Chicago School of Architecture. Root died suddenly in January of 1891, while deeply involved in planning the World's Columbian Exposition. Burnham quickly had to take over preparations for the fair as well as run the firm, which became known as D.H. Burnham & Company. Burnham had a long-term relationship with Chicago's South Park Commission, and his firm designed dozens of buildings for the parks. His visions for Chicago's lakefront featured prominently in his seminal 1909 *Plan of Chicago*, co-authored by Edward H. Bennett. Burnham also produced city plans for Cleveland, San Francisco, and Manila, and served on President Taft's National Commission of Fine Arts.

Alfred Caldwell (1903–1998). A disciple of Jens Jensen, Caldwell is known as the last Prairie style landscape designer of the twentieth century. Born in St. Louis,

Missouri, Caldwell settled in Chicago with his family during his early childhood. He briefly studied landscape architecture at the University of Illinois, but became disillusioned and quit school. In 1924, a family friend introduced him to Jensen, who became a life-long source of inspiration. For five and a half years, he worked in Jensen's private office in Ravinia (Highland Park), Illinois. After trying to establish his own practice during the Depression, Caldwell began working for the Parks Department of Dubuque, Iowa, in 1934. He had conflicts with the park board and was fired two years later. He went on to work for the Chicago Park District for several years, where his work included landfill extensions in Burnham and Lincoln parks, the Lily Pool in Lincoln Park, and Riis Park. Later, Caldwell worked with the renowned architect, Ludwig Mies van der Rohe, and taught at the Illinois Institute of Technology and the University of Southern California.

Formal design. Landscapes designed in a formal manner tend to emphasize straight lines and symmetry. Trees and other plants are generally arranged in straight rows, and hedges are often trimmed to create geometric patterns or uniform lines. One of the world's most notable formal landscapes is the seventeenth-century design by Andre le Nôtre for Versailles, near Paris, France. Chicago's most prominent, formally designed landscape is Grant Park.

Independent Park Districts. An 1895 act of the Illinois State Legislature allowed residents within areas that were not served by the South, West, and Lincoln Park commissions to form their own park districts. The law allowed that 100 voters within the boundaries of a proposed park district could petition the county court to bring the issue to popular vote. Between 1896 and the 1930s, 19 new districts were created, resulting in a total of 22 independent park commissions. These were consolidated into the Chicago Park District in 1934.

William Le Baron Jenney (1832–1907). An architect, engineer, landscape designer, and educator, Jenney studied civil engineering at Harvard University and the Ecolé Centrale des Arts et Manufactures in Paris. As an engineering officer during the Civil War, Jenney met Frederick Law Olmsted, who served on the United States Sanitary Commission. In 1868, when Olmsted laid out Riverside, Illinois, he hired Jenney to design numerous buildings for the seminal planned community. The following year, Jenney received the commission to create plans for Chicago's entire West Park System. He relied on his engineering expertise to alleviate drainage problems, and was inspired by the great parks and boulevards of Paris as well as advice from Olmsted. Jenney planned an extension to Chicago's Graceland Cemetery during the late 1870s, and he went on to design numerous commercial buildings in Chicago. Because he made important contributions to the development of the skeletal steel frame, Jenney is often considered the "father of the skyscaper."

Jens Jensen (1860–1951). Born into a prosperous family in the Slesvig region of Denmark, Jensen immigrated to the United States in 1884 to marry Anne Marie Hansen, of whom his parents disapproved. After settling in Chicago, Jensen found work as a laborer for the West Park Commission. Soon promoted to gardener, he noted that exotic plants did not thrive well in the Chicago parks. In 1888, Jensen began transplanting wildflowers from the countryside to Union Park, creating the *American Garden*. Jensen was appointed as superintendent of Union Park in 1894, and at the end of the following year he was promoted to superintendent of the larger, more prominent Humboldt Park. In 1900, in response to Jensen's efforts to fight against the politically corrupt West Park System, the commissioners fired him. Reappointed as general superintendent and chief landscape designer by a reform-minded board in 1905, Jensen began efforts to repair and complete

unfinished sections of Humboldt, Garfield, and Douglas parks. He soon began creating new small neighborhood parks, and between 1915 and 1920 Jensen designed Columbus Park, his first entirely new large park for the West Park Commission and generally considered his masterpiece. Throughout many of his years at the West Park Commission, Jensen also maintained a thriving private practice in Ravinia (Highland Park), Illinois, and participated in numerous conservation efforts such as preserving the Indiana dunes along Lake Michigan and helping to establish the Cook County Forest Preserves. Such conservation efforts were supported by organizations he founded, among them the Prairie Club and Friends of Our Native Landscape. In 1935, upon his retirement from private practice, Jensen established The Clearing, a school in Door County, Wisconsin, that still exists today. When he died at the age of 90, the *New York Times* called him the "dean of American landscape architecture." Today he is recognized also as the dean of the Prairie style of landscape architecture and the leader in the Midwestern conservation movement.

Lake Michigan and Chicago Lakefront Protection Ordinance. After Chicago's large convention hall, McCormick Place, burned down in 1967, civic groups hoped that it would be removed entirely from the city's lakefront. The structure, however, was soon rebuilt at the same location. This, and the 1968 construction of Lake Point Tower, a gleaming high rise on the edge of Lake Michigan, resulted in a public movement to protect Chicago's lakefront from development. As a result, this led to the adoption in 1973 of the Lake Michigan and Chicago Lakefront Protection Ordinance, which restricts and regulates development and construction along the lakefront. The ordinance sets forth specific policies for the careful review and scrutiny by the Chicago Plan Commission of proposed public and private changes to all property with a district within and surrounding Chicago's entire lakefront. The ordinance is published as Part D of the Chicago Zoning Ordinance.

Lincoln Park Commission. In 1869, three separate acts of the Illinois State Legislature established the Lincoln, South, and West Park commissions. At that time, the City of Chicago transferred its control of Lincoln Park to a newly appointed five-member board of the Lincoln Park Commission. Due to legal challenges by the residents of the towns of North Chicago and Lake View, the State Supreme Court determined that the city did not have the power to issue bonds to improve the park. Although the state approved an agreement allowing North Chicago and Lake View to make special assessments to improve and enlarge Lincoln Park, funding constraints and the commission's lack of autonomy hindered progress.

Naturalistic design. Landscapes designed in a naturalistic manner tend to include irregular masses of vegetation, curving lines, native plants, informal spaces, and natural looking bodies of water. They often appear as though they were created by nature, not by people. During the early eighteenth century, landscape gardeners, writers, and painters in England created interest in such natural-appearing scenery. Fostered by dissatisfaction with the topiary and straight lines of French and Italian gardens, this movement became known as the English School of Landscape Gardening. Early practitioners included Charles Bridgeman and William Kent; Lancelot "Capability" Brown contributed to the evolution of the English style during the later part of the century. In America, nurseryman and landscape gardener Alexander Jackson Downing helped promote a naturalistic style during the 1840s, and Frederick Law Olmsted, Jens Jensen, and other landscape designers continued expressing naturalistic ideals.

Swain Nelson (1829–1917). A Swedish immigrant who settled in Chicago in 1856, Nelson opened a landscape gardening business and was hired in 1861 to assist the nationally renowned designer, William Saunders, on the plan for Graceland Cemetery. During the mid-1860s, Nelson created original plans for Union and Lincoln parks. Responsible for implementing the Lincoln Park plan, he soon established an adjacent nursery. At the time, there were few other nurseries throughout America, so Nelson had trees shipped from England and Scotland. He was also known for moving large trees from the woods and transplanting them for ornamental purposes. It is believed that Jens Jensen worked for Nelson after his dismissal from the West Park Commission in 1900. By that time, Nelson had opened a second nursery in a Chicago suburb, and his sons had become involved with the business.

John Warner Norton (1876–1934). One of Chicago's most important muralists, John Warner Norton was educated at Harvard University and the School of the Art Institute of Chicago, where he also taught from 1914 to 1929. Norton collaborated with many of Chicago's most renowned architects. He created many noteworthy paintings and murals, including works in several Chicago parks, the Board of Trade, the Daily News Building, and *A Century of Progress* World's Fair.

Frederick Law Olmsted (1822–1903). Often considered the "father of American landscape architecture," Olmsted designed many of the nation's premier parks, boulevards, campuses, residential communities, and estate grounds of the nineteenth century. Born into a New England mercantile family, Olmsted held numerous positions before his appointment as superintendent of New York City's Central Park in 1857. The following year, he and architect Calvert Vaux entered the winning Greensward Plan in a competition to design Central Park. Olmsted became architect-in-chief of Central Park, leaving to serve as director of the U.S. Sanitary Commission during the Civil War. In 1868, Olmsted and Vaux laid out the town of Riverside, Illinois, the first planned suburban community in the nation. The following year, he was commissioned to design Chicago's South Park, a 1,055-acre landscape now known as Jackson and Washington parks and the Midway Plaisance. Olmsted was also responsible for laying out the fairgrounds for the 1893 *World's Columbian Exposition* in Jackson Park. His firm of Olmsted, Olmsted, and Eliot began transforming the site back into parkland in 1895. Olmsted's designs, philosophies, and writings continue to have a profound impact throughout the world and nation.

Olmsted Brothers. Frederick Law Olmsted's nephew and stepson, John Charles Olmsted (1852–1920), and son, Frederick Law Olmsted, Jr. (1870–1957), formed the Olmsted Brothers firm in 1898. Both brothers were college educated and had gained tremendous expertise and inspiration from working in their father's firm. For Chicago's South Park Commission, the Olmsted Brothers began designing the nation's first neighborhood parks in 1904, and continued with additional design commissions into the 1910s. Throughout the long tenure of the Olmsted Brothers, the firm produced plans for thousands of landscapes throughout the nation.

Prairie style. During the early twentieth century, a number of Chicago architects began using the Midwestern prairie landscape as a central design theme. In 1915, Wilhelm Miller, a professor of landscape architecture at the University of Illinois, published a bulletin identifying Jens Jensen and Ossian Cole Simonds as the originators of the Prairie style of landscape design. Both practitioners used native plant materials, emphasized horizontality, and incorporated a site's natural attributes into their designs.

Ossian Cole Simonds (1855–1931). Having studied architecture under William Le Baron Jenney at the University of Michigan, Simonds graduated in 1878, and moved to Chicago to work in his former professor's architectural office. Simonds had considerable engineering experience, and his first project was to help solve the drainage problems of a lake extension to Graceland Cemetery, which Jenney was then designing. Simonds soon became enamored with landscape gardening, which proved to be his calling. Simonds had great respect for the natural landscape, and as early as 1880 he began transplanting native plants from the countryside to Graceland Cemetery. He was appointed as the cemetery's superintendent in 1883, and, though he began accepting additional consulting work in 1888, he was involved in Graceland Cemetery's landscape for the rest of his life. Because of his innovative naturalistic approach and Graceland Cemetery's national prominence, he became known as the "dean of cemetery design." From 1903 to 1913 and from 1917 to 1921 Simonds served as consulting landscape architect for Chicago's Lincoln Park Commission. He served on many influential committees and organizations, including his role as a founding member of the American Society of Landscape Architects in 1899. Along with Jens Jensen, Simonds is recognized as co-pioneer of the Prairie style in landscape architecture.

South Park Commission. One of three original park commissions established by the Illinois State Legislature in 1869, the South Park Commission was originally responsible for a 1,055-acre park and the boulevards that would connect it with the other two systems. (Today, the original South Park is considered Jackson and Washington parks and the Midway Plaisance.) Legislation approved in 1903 allowed the commission to create additional parks within its service area on Chicago's Southside.

Special Park Commission. Formed by Mayor Carter Harrison in 1899, the Special Park Commission sought to study all of the existing parks, playgrounds, and open lands in the Chicago region, develop a consistent plan to satisfy the city's needs for recreation areas, and establish a metropolitan park system. It was also empowered to create or accept donations of parkland. In 1916, the commission was absorbed by the Bureau of Parks, Playgrounds, and Bathing Beaches, and in 1924 became the Bureau of Parks, Recreation, and Aviation. Many of the properties owned and managed by this bureau were transferred to the CPD as a result of the Functional Consolidation Act of 1959.

Calvert Vaux (1804–1895). In 1850, Andrew Jackson Downing, America's famous horticulturalist and landscape gardener, recruited English architect Vaux to help him develop a new American residential style. Seven years later, Vaux asked Frederick Law Olmsted to join him in preparing an entry for the competition to design Central Park. Winning the competition with their seminal Greensward Plan, the two formed a partnership that continued until 1872. Among Olmsted and Vaux's most notable works are the community of Riverside, Illinois, Prospect Park in Brooklyn, Buffalo's northside park system, as well as South Park in Chicago (later renamed Jackson and Washington parks).

West Park Commission. Established by the State of Illinois in 1869, the West Park Commission was one of the original Chicago park systems intended to be connected by an interlinking ribbon of boulevards. (The other two were the South and Lincoln Park commissions.) Originally known as North, Central, and South parks, the West Park System was later renamed Humboldt, Garfield, and Douglas parks. An 1885 law allowed city-owned parks on the West Side, such as Union Park, to be transferred to the West Park Commission. In 1907, the commission began to create new neighborhood parks on the city's congested West Side.

Works Progress Administration (WPA). As part of President Franklin Delano Roosevelt's New Deal Programs, the Works Progress Administration provided jobs in many different fields and occupations for tens of thousands of people throughout the United States. Funding through the program was made available to many public agencies, including the Chicago Park District.

Most of the research materials for this book, and the historic photographs depicted in it, were drawn from the Chicago Park District's Special Collections. This remarkable archive contains thousands of historic plans, drawings, manuscripts, photographs, negatives, and glass slides. In preparing this book, I have relied also on the writings, teachings, and research of many individuals. Below is a listing of readings that I recommend for those interested in learning more about the history of Chicago's parks and related matters.

Alanen, Arnold R., and Robert Z. Melnick, eds, with a foreword by Dolores Hayden. *Preserving Cultural Landscapes in America*. Baltimore: The Johns Hopkins University Press, 2000.

Bach, Ira, and Mary Lackritz Gray. *A Guide to Chicago's Public Sculpture*. Chicago: The University of Chicago Press, 1983.

Bachrach, Julia S., and Elizabeth Ann Patterson. *Chicago Parks: Historical Profiles*. May, 2000. (Available on the Chicago Park District's Web site: *www.chicagoparkdistrict.com*)

Beveridge, Charles E. *Frederick Law Olmsted: Designing the American Landscape*. New York: Universe Publications, 1998.

Birnbaum, Charles A., and Robin Karson. *Pioneers of American Landscape Design*. New York: McGraw-Hill, 2000.

Bluestone, Daniel. *Constructing Chicago*. New Haven: Yale University Press, 1991.

Breen, Daniel F., ed. *Historical Register of the Twenty-two Superceded Park Districts*. Chicago: Compiled under the supervision of the Division of the Secretary, Chicago Park District, Works Progress Administration, Project 30260, 1941.

Burnham, D. H., and E. H. Bennett. *Plan of Chicago*. Chicago: The Commercial Club, 1909.

Conzen, Michael P., and Kay J. Karr, eds. *The Illinois and Michigan Canal National Heritage Canal Corridor: A Guide to Its History and Sources*. DeKalb: Northern Illinois University Press, 1980.

Cranz, Galen. *The Politics of Park Design: A History of Urban Parks in America*. Cambridge: MIT Press, 1982.

Cronon, William. *Nature's Metropolis: Chicago and the Great West*. New York: W.W. Norton & Company, 1991.

Domer, Dennis, ed. *Alfred Caldwell: The Life and Work of a Prairie School Landscape Architect*. Baltimore: The Johns Hopkins University Press, 1997.

Drell, Adrienne, ed. *20th Century Chicago: 100 Years–100 Voices*. Champaign: Sports Publishing Inc., 2000.

Evans, Terry, with an introductory essay by Tony Hiss. *Disarming the Prairie*. Baltimore: The Johns Hopkins University Press, 1998.

Grese, Robert E. *Jens Jensen: Maker of Natural Parks and Gardens*. Baltimore: The Johns Hopkins University Press, 1992.

Halsey, Elizabeth. *The Development of Public Recreation in Metropolitan Chicago*. Chicago: Chicago Recreation Committee, 1940.

Hines, Thomas S. *Burnham of Chicago: Architect and Planner.* Chicago: The University of Chicago Press, 1974.

Jensen, Jens. *Siftings.* Chicago: Ralph Fletcher Seymour, 1939. Republished by the Johns Hopkins University Press, 1990, with a foreword by Charles E. Little and an afterword by Darrel G. Morrison.

Little, Charles E. *Greenways for America.* Baltimore: The Johns Hopkins University Press, 1990.

Mayer, Harold M., and Richard C. Wade. *Chicago: Growth of a Metropolis.* Chicago: The University of Chicago Press, 1969.

Miller, Donald L. *City of the Century: The Epic of Chicago and the Making of America.* New York: Simon & Schuster, 1996.

Olmsted, Frederick Law. *The Papers of Frederick Law Olmsted* (an ongoing, multi-volume series). Baltimore: The Johns Hopkins University Press, since 1977.

Ranney, Victoria Post. *Olmsted in Chicago.* Chicago: Open Lands Project, 1972.

Roper, Laura Wood. *F.L.O.: A Biography of Frederick Law Olmsted.* Baltimore: The Johns Hopkins University Press, 1974.

Rybczynski, Witold. *A Clearing in the Distance: Frederick Law Olmsted and America in the Nineteenth Century.* New York: Scribner, 1999.

Schuyler, David. *Apostle of Taste: Andrew Jackson Downing, 1815–1852.* Baltimore: The Johns Hopkins University Press, 1996.

Schuyler, David. *The New Urban Landscape: The Redefinition of City Form in Nineteenth-Century America.* Baltimore: The Johns Hopkins University Press, 1986.

Simonds, Ossian Cole. *Landscape Gardening.* New York: Macmillan, 1920. Republished by University of Massachusetts Press, 2000, with an introduction by Robert E. Grese.

Sinkevitch, Alice, ed. *AIA Guide to Chicago.* San Diego: Harcourt Brace & Company, 1993.

Sniderman, Julia, and William W. Tippens. "The Historic Resources of the Chicago Park District." National Register of Historic Places Multiple Property Documentation Form, U.S. Department of the Interior, 1989.

Sniderman, Julia, William Tippens, et. al. *A Breath of Fresh Air: Chicago's Neighborhood Parks of the Progressive Era, 1900–1925.* Chicago: The Chicago Public Library and the Chicago Park District, 1989.

Sniderman, Julia, William Tippens, et. al. *Prairie in the City: Naturalism in Chicago's Parks 1870–1940.* Chicago: The Chicago Historical Society, 1991.

Thall, Bob, with an essay by Peter Bacon Hales. *The Perfect City.* Baltimore: The Johns Hopkins University Press, 1994.

Tishler, William H., ed. *American Landscape Architecture: Designers and Places,* Washington, D.C.: The Preservation Press, 1989.

Tishler, William H., ed. *Midwestern Landscape Architecture.* Urbana: The University of Illinois Press, 2000.

Wille, Lois. *Forever Open, Clear, and Free: The Historic Struggle for Chicago's Lakefront.* Chicago: Henry Regnery Company, 1971.

Wilson, William H. *The City Beautiful Movement.* Baltimore: The Johns Hopkins University Press, 1989.

DURING THE SUMMER OF 2000, the Chicago Park District sponsored a gala event in Columbus Park to raise money for an interactive educational program to teach children about historic landscapes. Because the Cultural Landscape Foundation, of Washington, D.C., is undertaking this initiative, several prominent professionals from other cities were in attendance. That evening, after I led a trolley tour through several Chicago parks ending at the party in Columbus Park, Anthony Smith, director of the New York Horticultural Society, pulled me aside. He told me that this was his first time in Chicago and that he could hardly believe his eyes. He was overwhelmed by the city's gardens, street plantings, and especially our impressive park system.

Thanks to the efforts of Mayor Richard M. Daley, all of Chicago's citizens are enjoying the renewed greening of this great city. If it were not for Mayor Daley's vision and all the recent improvements in the parks under his leadership, this book would not have been possible.

It is a very exciting time at the Chicago Park District. I especially extend heartfelt thanks to David J. Doig, general superintendent, and Drew Becher, chief of staff, for their genuine passion for the parks and for the opportunity they provided to create this book. I also thank Gia Biagia, Bob Foster, Michael Fus, Lara Khoury, Robert J. Megquier, Robert Middaugh, Susan Moore, Caroline O'Boyle, Dan Purciarello, Kim Ryan, and Anita Salazar, of the CPD, for all their help and support on this project; thanks also to Caryl Dillon, of the Parkways Foundation.

I would like to recognize three dynamic citizens who are all extremely committed to Chicago's parks: Jo Ann Nathan, Cindy Mitchell, and Donna La Pietra. These influential and charismatic women have inspired innovative work on behalf of the parks and this book. And, over the years, a number of friends and colleagues have helped me to develop a body of research on the history of Chicago's parks that eventually led to this book. I am especially indebted to Elizabeth Ann Patterson, Timothy Wittman, Tim Samuelson, Will Tippens, and Robert E. Grese. I also thank Rolf Achilles, Arnold R. Alanen, and Bob Grese for carefully reviewing the manuscript and for providing helpful suggestions.

Judith Bromley and Jim Iska, the photographers who made the contemporary images in this book, certainly went above and beyond all expectations in terms of their commitment to the project. All of us are benefactors

of the quality of their work. I also thank Jordan Schulman and Beth Iska for assisting Judith and Jim, and my good friend Paul Lane, of Evanston, Illinois, for his meticulous work on scanning the historic images. I am also grateful to Rich Cahan, who gave valuable input on the photography. Rich is director of CITY 2000, a tremendous initiative to document Chicago during the year that separates the first and second millennia. I am extremely grateful to CITY 2000, the Parkways Foundation, the Graham Foundation for Advanced Studies in the Fine Arts, and numerous individuals who made this book possible through their generous support. I am also most grateful to Bill Kurtis for his thoughtful and insightful foreword, to David Skolkin, of Santa Fe, New Mexico, for his elegant book design, to Denis Wood, of Raleigh, North Carolina, for his careful proofreading, to Bruce Taylor Hamilton, of Santa Fe, for his timely editorial advice, to the University of Chicago Press for believing in the value of the book, and to Oddi Printing Ltd., of Reykjavik, Iceland, for producing a beautiful book of lasting value to citizens and collectors alike.

Last but not least, I thank George F. Thompson, president, and Randall B. Jones, editor and publishing liaison, of the Center for American Places for making the dream of a book on Chicago's parks a reality.

Julia Sniderman Bachrach was born in 1960 in Baltimore, Maryland. She received her B.A. in American culture studies from Roger Williams University in Bristol, Rhode Island, and completed her M.S. in landscape architecture at the University of Wisconsin, Madison. She is the author of the essay "Ossian Cole Simonds: Conservation Ethic in the Prairie Style," featured in *Midwestern Landscape Architecture* (Illinois, 2000), edited by William Tishler; she contributed entries to *20th Century Chicago, 100 Years–100 Voices* (Sports Publishing, 2000), edited by Adrienne Drell, and the *AIA Guide to Chicago Architecture* (Harcourt Brace, 1993), edited by Alice Sinkevitch; and she is co-editor of *Praire in the City: Naturalism in Chicago's Parks, 1870–1940* (Chicago Historical Society, 1991, in cooperation with the Chicago Park District and the Morton Arboretum). In addition, Ms. Bachrach has curated exhibits about Chicago's parks at the Chicago Historical Society, Chicago Cultural Center, City Gallery in the historic Water Tower, Nature Museum, Chicago Architecture Foundation, and in selected Chicago parks. She also serves on the board of the National Alliance for Historic Landscape Preservation and is a staff liaison to the Jens Jensen Legacy Project. Ms. Bachrach joined the Chicago Park District in 1988, where she is currently a park historian and preservationist for the department of planning and development.

Judith Bromley was born in Morristown, New Jersey, in 1944 and was raised there. She received her B.F.A. in photography at the Rhode Island School of Design, where she studied with Harry Callahan and later served as an assistant to Aaron Siskind. She moved to Chicago in 1983 and established Judith Bromley Photographs, in which as an artist she concentrates on portraiture and landscape and architectural studies. In 1995 she received a grant from the Graham Foundation for Advanced Studies in the Fine Arts to document the architecture of George W. Maher. Her photographs are in many private collections in the United States and Italy, and her architectural photographs have appeared in such magazines as *Architectural Record, Architecture, Atlantic Monthly, Garden Design, Historic Preservation, Home, House Beautiful, Metropolitan Home*, and *Progressive Architecture*. Ms. Bromley as photographer is co-author, with Kathryn Smith, of *Frank Lloyd Wright's Taliesin and Taliesin West* (Abrams, 1997) and a contributor to the *AIA Guide to Chicago* (Harcourt Brace, 1993), edited by Alice Sinkevitch. She also serves on the board of directors, as Vice President for Development, of the Frank Lloyd Wright Building Conservancy.

James Iska was born in Chicago in 1958 and was raised there. He received his B.S. from the Institute of Design at the Illinois Institute of Technology, and in 1982 he joined the Art Institute of Chicago where he is departmental specialist in the department of photography. Mr. Iska is also a professional architectural photographer whose work is in the permanent collections of the Art Institute of Chicago, Canadian Centre for Architecture, Chicago Historical Society, First National Bank of Chicago, La Salle National Bank of Chicago, Museum of Contemporary Photography in Chicago, Museum of Fine Arts in Houston, and Parnassus Foundation in New York City, among others. Mr. Iska as photographer is co-author, with Francis Morrone, of *An Architectural Guidebook to Brooklyn* (Gibbs Smith, 2001), *An Architectural Guidebook to New York City* (Gibbs Smith, 1998), and *An Architectural Guidebook to Philadelphia* (Gibbs Smith, 1998). He also served as a contributing photographer to *Changing Chicago: A Photodocumentary* (Illinois, 1989), edited by Naomi Rosenblum and Larry Heinemann, and *Money Matters: A Critical Look at Bank Architecture* (McGraw-Hill, 1990), by the Museum of Fine Arts, Houston.

THE CITY OF CHICAGO

Mayor of Chicago

Richard M. Daley

Chicago Park District

Board of Commissioners

William C. Bartholomay

Dr. Margaret T. Burroughs

Mona Castillo

Anita M. Cummings

Bob Pickens

Gerald M. Sullivan

General Superintendent

David Doig

Chief of Staff

Drew Becher

Chief Administrative Officer

Diane E. Minor

For more information about your *Chicago Park District* visit: www.chicagoparkdistrict.com or call 312.742.PLAY, tty: 312.747.2001

THE PARKWAYS FOUNDATION, *private funding, public greatness,* is your way of giving to Chicago's parks. For more information visit: www.parkways.org or call 312.743.4804

Curated by
Julia Sniderman
Bachrach

CITY GALLERY IN THE HISTORIC WATER TOWER

21 June –16 September 2001

PEGGY NOTEBAERT NATURE MUSEUM

20 September – 17 November 2001

GARFIELD PARK CONSERVATORY

21 November – 27 January 2002

CHICAGO ARCHITECTURE FOUNDATION

31 January–6 April 2002

A version of this exhibit can also be seen on line:
www.americanplaces.org.

THE CENTER FOR AMERICAN PLACES, a tax-exempt 501(c)(3) nonprofit organization, was founded in 1990 by George F. Thompson, a former Johns Hopkins University Press editor, with writer Charles E. Little and fellow founding board members J.B. Jackson, Cotton Mather, Yi-Fu Tuan, Bonnie Loyd, Gregory Conniff, Martha A. Strawn, William Howarth, Thomas C. Hunt, Dick Beamish, and Henry Y.K. Tom.

The Center's educational mission is to enhance the public's understanding of, and appreciation for, the natural and built environment. It is guided by the belief that books, especially illustrated books, provide an indispensable intellectual and affective foundation for comprehending the places where we live, work, and visit. Books live. Books endure. Books make a difference. Books are gifts to civilization.

With offices in Virginia and New Mexico, Center editors are bringing to publication 20–25 books per year under the Center's own imprint or in association with its publishing partners. More than 200 titles have been published to date, nearly a third of them prize winners; another 100 books will be released during the next five years.

To complement the Center's book publishing program, it sponsors lectures, seminars, and workshops on various place-based topics for all ages; organizes and curates exhibitions of photography and the visual arts at leading museums, galleries, and other public venues in America and around the world; fosters geographical research and conducts educational fieldwork; and assists with curriculum development and classroom instruction with an emphasis on the interpretation of *place* through art, literature, and scholarship. The Center's Cotton Mather Library is in Arthur, Nebraska, and the Martha A. Strawn Photographic Library is in Davidson, North Carolina. A 10-acre field station along the Santa Fe River in Florida is also available upon request.

The Center for American Places strives every day to make a difference through books, research, and education. For more information, please visit the Center's Web site (www.americanplaces.org) or send inquiries to P.O. Box 23225, Santa Fe, NM 87502, U.S.A.

"It is hard to imagine concretely how we can envisage the good life (the humane life), and plan for the future, unless we have some clear idea as to the sort of places that we wish to exist."

YI-FU TUAN,
*Founding Director,
Center for
American Places*

COLOPHON

The text for THE CITY IN A GARDEN was set in Centaur, designed by Bruce Rogers in 1914 as a titling font exclusively for the Metropolitan Museum of Art, of New York City, and modelled on Jenson's Roman. The italic cut to accompany the Monotype Corporation's version of Centaur is the Arrighi italic, designed by Frederic Warde in 1925.

Duotone separations, printing, and binding by Oddi Printing Ltd., of Reykjavik, Iceland, on acid-free Silk Mediaprint paper, 150 gsm weight.

Project director: George F. Thompson, president, Center for American Places
Designed and typeset by David Skolkin, of Santa Fe, New Mexico
Production coordinator: Charles B. Gershwin, of Wyncote, Pennsylvania

Cover Photographs: (front) Grant Park, Spring, 2000, James Iska
(back) Humboldt Park, ca. 1906, CPDSC.